Portrait of Picasso

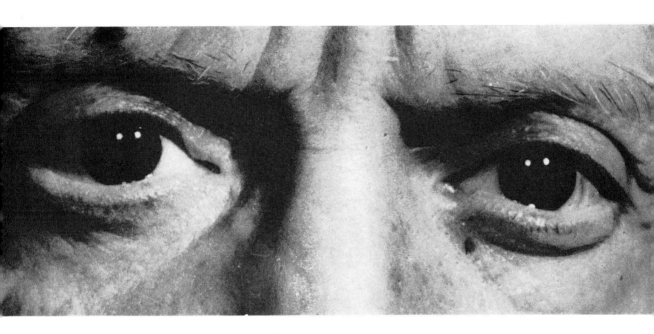

Roland Penrose

Portrait of Picasso

The Museum
of Modern Art
New York

Copyright © 1971 Sir Roland Penrose
First edition 1956. All rights reserved.
Second revised and enlarged edition 1971.
The Museum of Modern Art
11 West 53 Street
New York, New York 10019
Library of Congress Catalog Card Number 71–162311
Cloth binding ISBN 0–87070–536–9
Paperbound ISBN 0–87070–535–0
Designed by Herbert Spencer, Hansje Oorthuys
and Brian Coe
Made and printed in Great Britain
by Lund Humphries, Bradford and London

Frontispiece:
Picasso: Self-Portrait. 1904
(Indian ink and water-colour, $6\frac{1}{2} \times 4$).
Collection Dora Maar
Reproduced from
Pablo Picasso, Aquarelle und Gouachen
by John Richardson,
published by Holbein-Verlag AG.
Ektachrome by André Thevenet, Paris

Preface to first edition by Alfred H. Barr, Jr

Suppose the camera had been invented 500 years before Picasso.
Think what photographs we might have had! Ghiberti standing
beside his prize-winning relief for the Baptistry doors ('third from
the left, with the disgruntled expression, is Brunelleschi, the
runner-up'); Grand Duke Basil Dmitrevich handing Andrei
Rublyov the contract for the new frescoes in the Cathedral of the
Dormition; 'Petrus Christus Paints a Picture' – a series of
documentary photographs with captions by Antonello da Messina;
Michelangelo, perched on his scaffolding under the Sistine ceiling,
his beard clotted with plaster, shouting his anger at Pope Julius
down below; or, finally, and just to settle a long argument, Hubert
van Eyck, himself, at work on the Ghent altarpiece.

How Picasso will ultimately rank with these heroes of the past we
cannot be sure. There may even be a few stubborn eccentrics who
would deny that he is the greatest contemporary artist. But no one
can convincingly refute the statement that he is far and away the
most photographed of living artists. As evidence of this one may
point to the number of photographs Roland Penrose has chosen for
this volume, and even more to the hundreds he has had to omit.

Photo by André Villers.

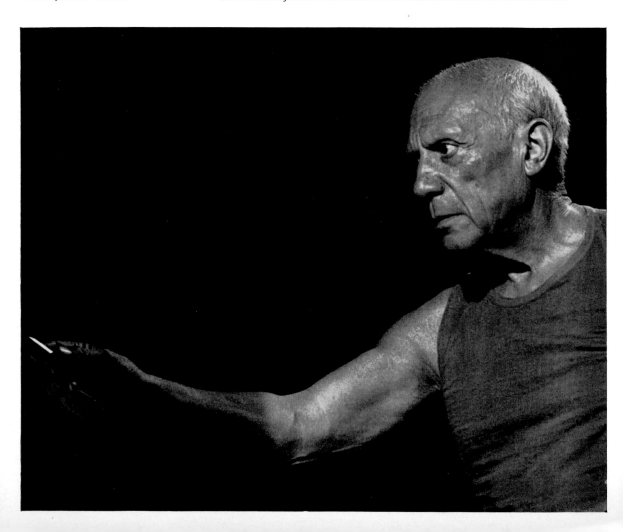

Why is Picasso so continually subject to photography? Because he is an immensely famous artist? A controversial figure? Yes, of course. But there are other reasons which have little to do with his reputation, though much to do with his personality and appearance.

As many of our best photographers have discovered, Picasso is extraordinarily interesting to watch: when he is gay he is irresistibly charming; when he is angry his eyes seem diabolical; even when he is morose or bored his face is arresting.

And, apparently Picasso likes to be photographed. Sometimes, it is true, he has turned on a persistent snapshooter with fury, but ordinarily he seems as obliging to photographers as a movie star or a political candidate. He will even put on a comical act with a false moustache, trick spectacles or a cowboy hat as if he felt that his ordinary appearance were not sufficient. Yet Picasso needs no publicity and his self-esteem is fed to surfeit in a dozen other ways. Watching him being photographed one feels that he is behaving much as he does when one sees him receiving time-wasting guests or looking over the drawings of some young artist. He seems moved primarily by a deep sense of courtesy rather than by vanity.

This book is, of course, not limited to images of Picasso. Pictures of his ancestors, his relatives, his many studios, his friends, the women he loved, his children, combine to document the background and foreground of his life. Assembled by the editor after long and diligent search, they are presented here with exceptional authority.

Roland Penrose is a painter, a poet, an essayist, an organizer of highly original exhibitions, and by far the most adventurous English collector of his generation. During the past thirty-five years he has lived much in France and has come to know Picasso intimately. Though recently he has done extensive research in preparation for his forthcoming biography of the artist, his approach is essentially that of a devoted friend. It is very fitting that *Portrait of Picasso*, which Roland Penrose and his publishers planned as a salute to Pablo Picasso on his seventy-fifth birthday, should be the work of a man whose scholarship is warmed and deepened by an affectionate personal understanding of his subject.

The material in this book was collected in connection with an exhibition entitled Picasso Himself *organized by Roland Penrose and first held in 1956 at the Institute of Contemporary Arts of London on the occasion of the seventy-fifth birthday of Pablo Picasso and later it was amended and published in connection with the exhibition held from May to September 1957 at The Museum of Modern Art, New York. The present edition has been considerably enlarged and brought up to date so as to coincide with the ninetieth birthday of Pablo Picasso on October 25th 1971.*

Foreword

It is ninety years since Pablo Picasso was born in Malaga. He now lives near Mougins in the South of France and the fame of his creative work is known throughout the world. It has been my purpose in this study to give a visual record of the life of Picasso by assembling portraits, sketches, photographs, and documents which have a direct bearing on the artist himself, his friends, and his surroundings up to the present time. It is my belief that, although it cannot be complete, this may serve as a background against which it will become easier to understand both the revolutionary changes that have taken place periodically and the less obvious stream of continuity that runs persistently through his work.

This biographical survey has been made possible in the first place by the co-operation of the artist himself, to whom I am greatly indebted. Many of his friends have also generously contributed valuable documents and advice. In particular Monsieur Jaime Sabartés was until his death an unfailing source of information. My thanks are also due for help in the initial stages of this book to Mr Alfred H. Barr, Jr, author of one of the most comprehensive works on the artist*, and to M. Daniel-Henry Kahnweiler, one of Picasso's most intimate and oldest friends. Invaluable help was also given me by Jean Cocteau, Bernhard Geiser, André Lefèvre, Tristan Tzara and Christian Zervos and I was very grateful for the assistance of M. Paul Picasso, the artist's elder son, M. Heinz Berggruen, Mme Rosamond Bernier, M. Gérald Cramer, M. Louis Dalmas, Mme Dominique Eluard, Mr Eric Estorick, Mr Sidney Janis, Mme Renée Laporte, Mlle Dora Maar, Mr Man Ray, M. H. Matarasso, Mr Jacques O'Hana, Mr John Richardson, M. Siegfried Rosengart and Mr James Thrall Soby.

In more recent years I owe an incalculable debt to Madame Jacqueline Picasso whose presence has made my visits to Cannes and Mougins a continuous pleasure. She has generously allowed me to include some excellent photos that she has taken.

In addition I must thank many others who have recently been most helpful in providing me with information and photographic material. Among them in particular are M. and Mme Michel Leiris, M. Jean Leymarie, M. Maurice Jardot, Mlle Richet, Miss Joanna Drew, Mrs Barbara Bagenal and Miss Joyce Reeves.

It is thanks to the collaboration of a number of distinguished photographers past and present that a composite portrait of Picasso can be made: Barbara Bagenal, Cecil Beaton, Hjalmar Boyesen, Brian Brake, Henri Cartier-Bresson, Robert Capa, Lucien Clergue, John Deakin, Robert Doisneau, David Duncan, Douglas Glass, Alexander Liberman, Dora Maar, Gjon Mili, Lee Miller, Inge Morath, Peter Rose Pulham, Jacqueline Picasso, Edward Quinn, Man Ray, Sanford H. Roth, André Thevenet, and André Villers.

* ALFRED H. BARR, JR
Picasso. Fifty Years of his Art. 1946.
The Museum of Modern Art, New York.

10

Introduction

In 1881, Pablo Picasso was born at Malaga into a world very different from that in which we live today; but we have grown accustomed to spectacular and dramatic changes with characteristic ease, and discoveries which at that date seemed incredible are now considered commonplace. Man has been borne along at a dizzy speed into the hazards and wonders of the atomic age. The advances of science have been welcomed greedily with little thought as to their consequences and new and more dazzling inventions are awaited with the eagerness of a child hoping for a new toy. It is, however, noticeable that society did not greet with equal enthusiasm the revolution that happened during the same period in the arts. Here, every development was received with violent and stubborn opposition. The work of all advanced artists was and often still is associated with blasphemy, obscenity, insanity, and immorality. Politically it has been considered to be a symbol of treason: witness the cries of *sales Boches* at the first performance of *Parade* in Paris in 1917, and the term 'Bolshevik Art' which paradoxically has been used to describe those forms of art that have been severely discouraged in the U.S.S.R. for more than fifty years.

Accepting and even enjoying the innovations of science, the artist has still continued to perform his ancient function, the discovery of new forms of expression. The refusal of society to admit the validity of his work has in no way deterred him. It has on the contrary added zest.

In the last two decades, however, the situation has changed. Already it is difficult to remember how violent was the struggle. The work of those who rebelled is now shown in places of honour and the term *avant garde* is ceasing to retain its former meaning. The talent and imagination of the pioneers is still evident but it is easy to forget their courage and the challenge they made to basic problems of aesthetics and the relationship between art and life. The accepted conceptions of good taste, common sense, and beauty which in 1881 were revered as yardsticks by which society could safely form its judgements have been questioned. Even beauty itself is now uncertain of its name. But the wearied and discredited concepts of the past have not been destroyed by theorists and scholars but by the creative work of artists who have discovered new means of expression and opened our eyes to new forms of vision.

A movement of such consequence could only happen when a direction was given to it by men of genius. The past seventy-five years have in fact been made exceptionally rich by the work of painters who have contributed in various ways to the history of contemporary art, but no single man has influenced this revolution more profoundly than Pablo Picasso.

So important to us at the present time are the many aspects of

the work of this prodigious artist that, rather than wait for the balanced judgement of posterity and at the risk of failing to place each detail in its proper perspective, I have taken here the course of making a visual survey of the life and work up to the present time of an artist who is still very much alive and producing work which is astonishing both in its quality and its quantity in spite of his venerable age.

Picasso, in voluntary exile in France, has become more widely known during his lifetime than any painter throughout history. This achievement is all the more notable when we remember the scorn with which his early discoveries were greeted. It is a phenomenon that must be of interest to all students of human life. As his age increases so does his reputation which now places him among the greatest painters, sculptors, engravers and poets, past and present. At the same time his work, the clarity of his thought, and the richness of his imagination continue unimpaired.

Photographers, biographers

Picasso is above all preoccupied with vision and it is therefore appropriate that a visual record should be made of the surroundings in which he was born and in which he has chosen to live, the friends he has made and the women who have shared his intimacy. By so doing we can gain insight into both his work and his character, we can divine the influences that have combined to inspire him and perhaps shed some light on the strange and incalculable workings of genius.

A visual record of the life of Picasso became increasingly easy to establish as time passed owing to the development of photography. Although in early days photographs were scarce and many events passed unrecorded, the ubiquitous camera now provides a surplus of images from which to select. It is fortunate that Picasso himself is usually not unwilling to be photographed and even more important that several distinguished photographers have become his close friends.

1

2

5

3

6

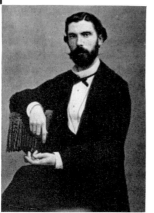

7

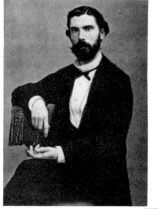

4

8

Pablo Picasso
born Malaga 1881

Origins and early youth

1
The Venerable Almoguera. 1605–76. Bishop of Arequipa, Archbishop of Lima, Viceroy of Peru. Brother of a paternal ancestor.

2
Brother Pedro de Cristo Almoguera. 1773–1855. Lived as a hermit in the mountains of Cordova. Brother of a paternal ancestor. The flowers were painted on the frame by Picasso's father.

3
Don Diego Ruiz de Almoguera, *grandfather* of Picasso. Born in Cordova, 1799; lived in Malaga.

4
Don José Ruiz Blasco, *father* of Picasso. Born in Malaga c.1850, died in Barcelona in 1913. Painter and art master in Malaga, Coruña, and Barcelona.

5
Doña Maria Guardeno. *Great-grandmother* of Picasso.

6
Don Francisco Picasso Guardeno. Born in Malaga and went to school in England. Became a customs officer in Havana where he died in 1883. *Grandfather* of Picasso.

7
Doña Inez Lopez Robles. *Grandmother* of Picasso. Lived in Malaga.

8
Doña Maria Picasso de Ruiz. Born in Malaga in 1855, died in Barcelona in 1939. *Mother* of Picasso.

9 (right)
Birthplace of Pablo Picasso, Plaza de la Merced, Malaga. Photo by Lee Miller.

The story of the origins, infancy, and youth of this child with piercing black eyes, born with an irrepressible desire to draw and paint, has been told by Picasso's old friend, Jaime Sabartés.★ He has unearthed from documents the existence among Pablo's ancestors of austere dignitaries of the church, and revealed remote descent on the paternal side from the fifteenth-century hidalgos of the Spanish province of León. On the side of Pablo's mother, whose family name was Picasso, Sabartés had discovered links with a fashionable Genoese portrait painter of the early eighteenth century, Matteo Picasso. But there is still some doubt as to the Italian origins of Picasso, and as far as both branches of the family can be followed with any certainty they were predominantly Andalusian.

The family left Malaga, the birthplace of Pablo, when he was 10. Three years later at Coruña his father, Don José Ruiz Blasco, an honourable bourgeois painter in the academic tradition and art master in the local institute, finding that he was outstripped by his son in his own art, handed over to him once and for ever his paints and brushes. The speed with which Pablo's talent developed and the ease with which he subsequently astonished his examiners in the more exacting academies of the fine arts in Barcelona and Madrid suggest that he would have had no trouble in finding for himself an easy road to success. But disregarding the advice of his family, the infant prodigy chose to become *l'enfant terrible*.

★ JAIME SABARTÉS.
Picasso, Documents Iconographiques.
Pierre Cailler (Geneva, 1954).

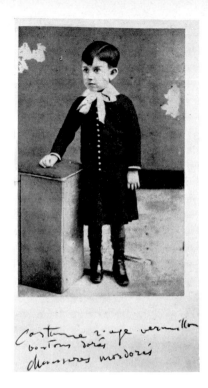

10
Pablo, aged 4. (Translation of note by
Picasso: 'Vermilion red costume, gold
buttons, bronze colour shoes'.)

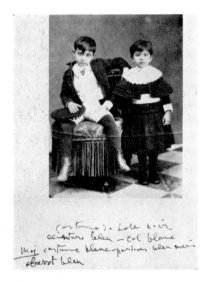

11
Pablo, aged 7, and his sister Lola.
(Translation of note by Picasso:
'Lola's dress; black with blue belt,
white collar. Myself; white costume,
navy blue overcoat, blue beret'.)

12
Picasso: *The Matador*. Earliest known
painting by Picasso. 1889–90 (oil).

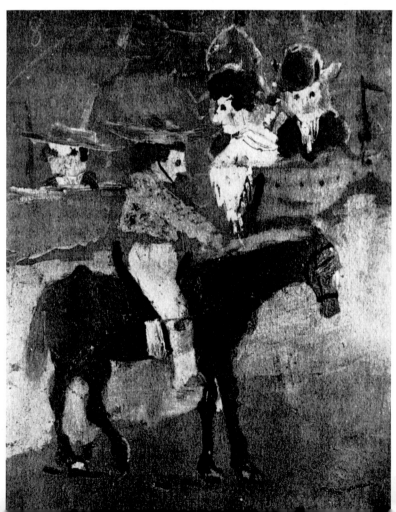

13
Picasso: *Portrait of Don José*. 1895.
(Water-colour with inscription, 'To my
dear Antonio Muñoz Degrain, I send
this Christmas present with my
affection. P. Ruiz Picasso 12.95' –
Translation.) Muñoz Degrain was a
painter well known throughout Spain,
a resident of Malaga, and a friend of
the family. Municipal Museum, Malaga.

14
Art School of San Telmo, Malaga.

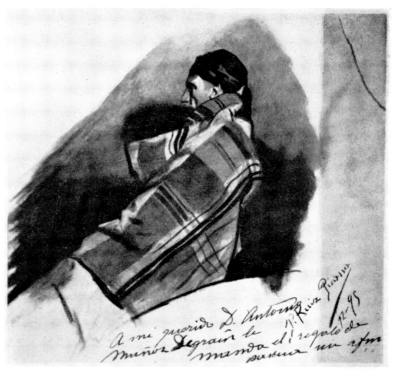

15
Painting by Don José Ruiz Blasco.

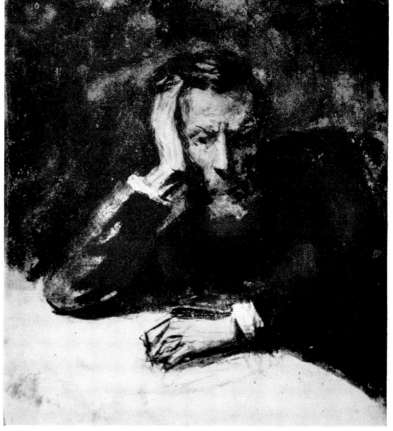

16
Picasso: *Portrait of Don José, the
artist's father*. 1895 (water-colour).

Barcelona and 'Els Quatre Gats'

After four years in Coruña, Don José obtained a post as professor in the School of Fine Arts in Barcelona. The family, consisting of Pablo's parents, his sister Lola, who often sat for her brother as a model, and himself, moved to this city, which being near the French frontier was more closely in touch with intellectual movements abroad. Pablo had no difficulty in passing the entrance tests for an academic career, but found very soon that he had nothing more to learn from his teachers. The lonely path of self-discovery and the consequences of his own unusual powers led him towards a small group of poets and painters. These Catalan intellectuals had founded an ephemeral, revolutionary tavern, 'a Gothic beer hall for those amorous of the North', known as *Els Quatre Gats*, the Four Cats. In their bohemian company the prevailing attitude was a desperate anarchic desire to rebel against the existing order, combined with a *fin de siècle* decadence and an urge to suffer as *le poète maudit* in order to prove their complete integrity. The group

17
Picasso: *Portrait of the artist's mother;* drawn soon after their arrival in Barcelona in 1895 (pastel). Museo Picasso, Barcelona.

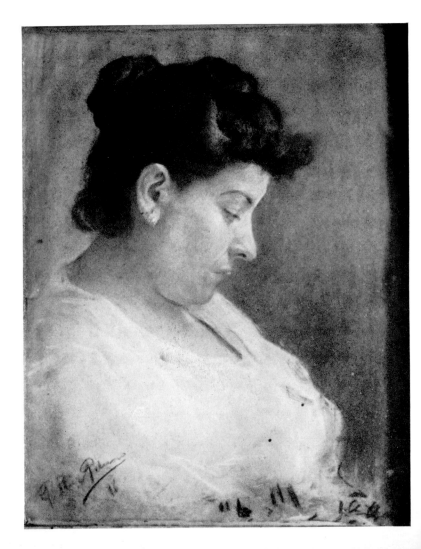

was led by the artist-playwright Santiago Rusiñol, the critic Miguel Utrillo, the fashionable portraitist Ramón Casas, and the painter of outcasts Isidro Nonell. They accepted as their host the genial entertainer Pere Romeu and attracted around them the most talented and arrogant youth of the city. Among them, Picasso made the acquaintance of the painters Ramón Pichot, Ricardo Opisso, Sebastian Junyer-Vidal, Juan Vidal Ventosa, Ricardo Canals, the sculptor Manolo Hugué, and the poets Ramón Reventos and Jaime Sabartés. Although he continued to live with his family he showed a degree of independence in his work which led him away from the academic traditions of his father and towards the discovery of a new school of painting.

In spite of their native pride, the aspirations of the Catalonian intellectuals turned towards the achievements of artists and poets in France, England, Scandinavia, and Germany. Following this current, Picasso paid his first visit to Paris in the autumn of 1900. His companion was a painter, Carlos Casagemas, whose career was brought abruptly to an end by suicide due to unrequited love.

18
Picasso, aged 15. Barcelona, 1896.

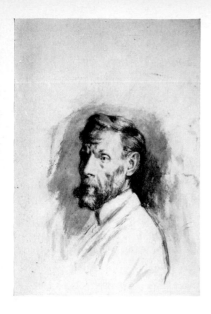

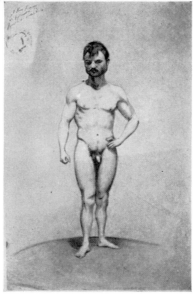

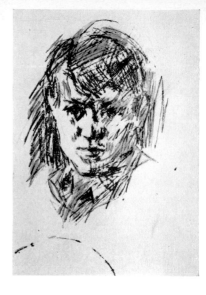

19
Picasso: *Portrait of Don José*. 1896.
Museo Picasso, Barcelona.

20
Picasso: *Diploma drawing for the
entrance examination to the School of
Fine Arts* (*La Lonja*). Barcelona, 1895
(lead pencil).

21
Picasso: *Self-portrait*.
Barcelona, 1896 (lead pencil).

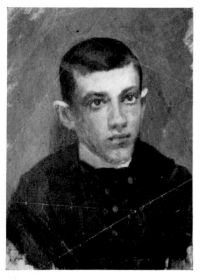

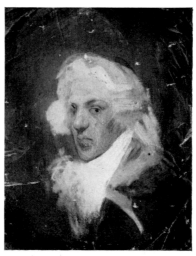

22
Ruiz: *Portrait of Pablo Ruiz Picasso*
by a friend in Barcelona, 1896 (oil).

23
Picasso: *Self-portrait in eighteenth-
century costume*. Barcelona, 1896 (oil).
Museo Picasso, Barcelona.

24
Diploma of 'Honourable Mention'
awarded at the Exhibition of Fine Arts,
Madrid, 1897, for the painting *Science
and Charity*.

25
Picasso: *Self-portrait*.
Barcelona, 1897 (charcoal).

26
Opisso: *Picasso and Pere Romeu at Sitges*. 1898.

27
Picasso: *Science and Charity*. 1896
(oil). Picasso's father set this subject
and posed for the seated doctor.
Museo Picasso, Barcelona.

28
Horta de San Juan. After falling
ill in Madrid, Picasso spent several
months in the spring of 1898 at the
house of his friend the painter Manuel
Pallarés.

29
Cave in the mountains near Horta.
Picasso lived here for a while with
Pallarés.

Picasso was left to find his own friends among the Spanish and French artists who frequented Montmartre.

For the next four years, he divided his time between Barcelona, Madrid, and Paris. At an earlier date he had visited the Spanish capital to study at the Royal Academy of San Fernando, but after a brilliant entrance, disillusionment and illness soon caused him to return to Barcelona. His second visit in the spring of 1901 was in the company of a Catalan writer, Francisco de Assis Soler, with whom he made a brief attempt to launch *Arte Joven*, a journal of which Picasso made himself the art editor and sole illustrator of the two rare numbers that appeared. Again, Madrid failed to provide the stimulus he required, and he left within a few months for Paris, his real spiritual home. The prestige and the turbulent atmosphere of this centre of the arts induced him to move permanently to the French capital in 1904. By then, a temperament of restless inquiry had helped him to discover and absorb the great variety of styles, ancient and contemporary, that he found on view in the museums and dealers' galleries. With the originality of one who can understand and interpret the work of others and yet preserve in his own work the strength of its individuality, he passed through the many influences around him, developing his own style with unceasing vigour. During the period of transition between Spain and France, the early subject matter emanating from the atmosphere of the Moulin Rouge gave way to the ghostlike outcasts from the streets and cafés of Barcelona and Paris. Their forms were bathed in a blueness which gave rise to these paintings being classified as the Blue Period. Instinctively, Picasso disliked exhibiting his work at the yearly salons, even in company with the more revolutionary groups, but at first in Barcelona and later in Paris dealers offered to show his work. They were rewarded by the immediate enthusiasm of a few enlightened critics. Max Jacob, who at the time was writing art criticism, was so struck on the opening day of Picasso's first exhibition in Paris at the gallery of Ambroise Vollard that he went at once to Picasso's studio to make his acquaintance. Their understanding of each other in spite of language difficulties was immediate. The character of the poet, both waggish and passionate, was congenial to the eager curiosity of his friend. Their meeting was the beginning of a lifelong intimacy, and the first link in the chain of friendships which extended to Guillaume Apollinaire, André Salmon, Alfred Jarry, Pierre Reverdy, Maurice Raynal and many other poets. Instinctively they found their way to Picasso's studio in Montmartre. This comfortless abode formed part of a strange dilapidated building known in derision as the 'Bateau Lavoir', but according to Salmon it should have had inscribed above the door, *Au rendez-vous des poètes*. Picasso joined this hive of struggling artists in 1904. He lived, worked, and entertained his friends there until he moved in 1909 to larger and less bohemian quarters in the nearby Boulevard de Clichy.

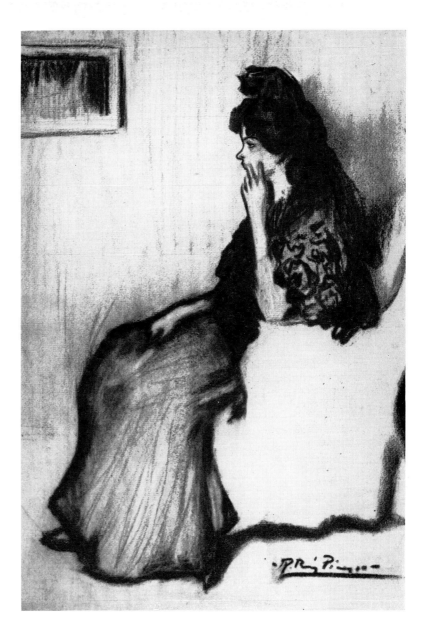

30
Picasso: *Portrait of Lola*. 1898
(pastel 16 × 11¼).
Col. Mrs Howard Samuel.

Although in his friendships Picasso has more often sought the company of poets than of painters, from early days the 'Bande Picasso' included, among his compatriots, the sculptors Manolo (Hugué), Gargallo, Gonzales, and the painters Pichot and Canals. In the early days of Cubism it was joined by Juan Gris. Matisse, Derain, Léger, the Douanier Rousseau, and Marie Laurencin, the mistress of Apollinaire, were all familiar visitors, but the friendship among painters that proved to be of the greatest importance was also the longest to survive. The name of Georges Braque must always be associated with that of Picasso in the great discoveries that led the Cubist movement to its height in the years between 1908 and 1914.

The life in this circle of talented youth was of a rare intensity. Enthusiasm, energy, boisterous enjoyment, and brilliant but relentless humour were balanced by an overwhelming dedication to work based upon jealous and passionate love. Raynal, Salmon, Gertrude Stein, and Fernande Olivier describe a strange variety of events, such as the banquet given in honour of the Douanier Rousseau in Picasso's studio, the expeditions to the Lapin Agile, to the Cirque Medrano, or across the Seine to the literary hierarchy of the Closerie des Lilas. These were punctuated by the weekly

31
Picasso: *Poeta Decadente*. Portrait of Jaime Sabartés. 1899 (charcoal and pastel, $18\frac{1}{2} \times 12\frac{1}{4}$). Museo Picasso, Barcelona.

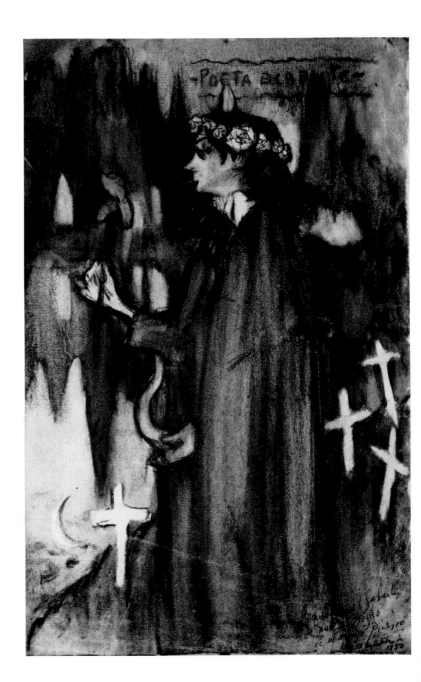

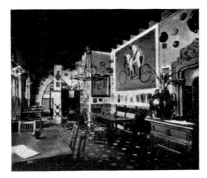

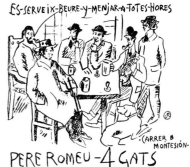

dinner parties given by the Steins which were attended by a well-picked cosmopolitan array of talent. Owing to the rarity of photographs in the years preceding the twenties, however, there are no visual records of these events, nor even of the interior of the 'Bateau Lavoir', with its stacks of freshly painted canvases. Even later, in 1917, there are no photos of Picasso's wedding, at which Apollinaire and Max Jacob were witnesses. But this scarcity is balanced, in addition to his production of great numbers of finished drawings and portraits, by Picasso's habit of making rapid sketches and caricatures of himself and his friends. These vivid images continue as a record until Picasso temporarily abandoned realistic drawing during the Cubist period. It is through them, as well as through the drawings that his friends made of him, that we can still clearly see the features of Picasso and the intensity of his expression, centred in the unchanging blackness of his eyes. Through these lively records we can understand better his passion for Fernande Olivier, who shared with him the years of poverty, his friendship for Gertrude Stein, and his enjoyment of the fertile companionship of Apollinaire and Max Jacob.

We can trace also the close association between the artist and the characters of his own invention. Just as under the instruction of his father he painted Don José as the doctor in the early set piece *Science and Charity* (see No. 27), so he sees himself later among the blind beggars and the absinthe drinkers. His most persistent impersonation at that time was Harlequin (see No. 71). Later, after the change of mood which coincides with his settling in Paris and his love for Fernande Olivier, that change which led him to turn from the pathos of the Blue Period to the more serene detachment of the circus folk and the 'Saltimbanques', Harlequin reappears intermittently as a self-portrait, until finally all direct likeness vanishes and only the diamond shapes of his costume continue to reveal his presence in Cubism.

34
Casas: *Portrait of Picasso.*
Reproduced in *Pel y Ploma,* Barcelona,
June 1901, to illustrate the first review
of an exhibition of Picasso's pastels
by Miguel Utrillo. In the background
on the right is one of the windmills of
Montmartre and on the left a theatre in
Barcelona.

36 (right)
Picasso: *Self-portrait.* 1901. Soon
after the second arrival in Paris. The
figure with a beard smoking a pipe is
Jaume Andreu Bonsons. In the
background is the Moulin Rouge with
the price of entry announced as
three francs. The writing up the side
of the drawing is not by Picasso
(pen and coloured crayon, $7 \times 4\frac{1}{2}$).
Mrs E. Heywood-Lonsdale.

35
Picasso: *Self-portrait with Casagemas.*
1899.

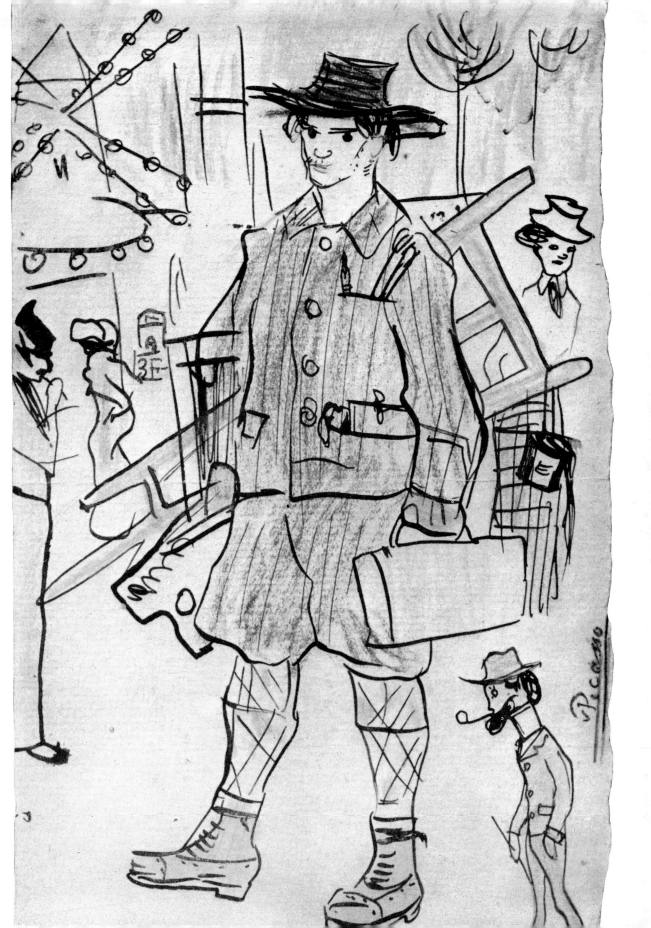

37
Picasso: *The Blue Room*. 1901 (oil, $20 \times 24\frac{1}{2}$). Phillips Collection, Washington. Picasso's studio at 130ter Boulevard de Clichy. On the wall hangs Toulouse-Lautrec's poster of May Milton.

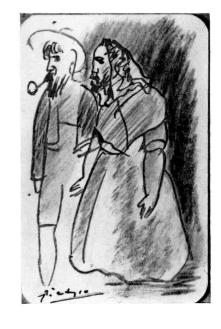

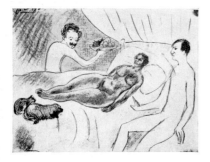

38
Picasso: *Group of Artists in Madrid*. 1901. Left to right: unknown, Cornuti, Francisco de Assis Soler, Picasso, Alberto Lozano (crayon).

39
Picasso: *Self-portrait with Francisco de Assis Soler*. 1901. Crayon drawing from *Arte Joven* announcing *Madrid*, a review which never appeared. Picasso was to have been art editor and Soler the editor.

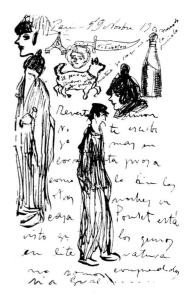

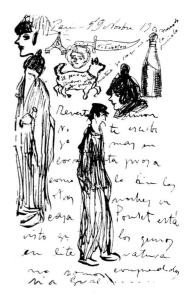

40
Picasso: *Self-portrait with nude and S. Junyer-Vidal*. 1901. A parody of Manet's *Olympia*.

42
Picasso: *Part of a letter to the poet Ramón Reventos*. Paris 9 November 1900.

43
49 rue Gabrielle, Paris, Picasso lived
here during his first visit to Paris, 1900.
It was formerly the studio of the Catalan
painter Nonell.

44
Picasso (seated) in his studio,
Boulevard de Clichy, 1901. On his
right is his friend Petrus Manach,
and on his left Fuentes Torres and his
wife. The inscription says: 'Me in the
studio. Au revoir.'

45
Picasso: *Self-portrait in top hat.*
Paris, 1901.

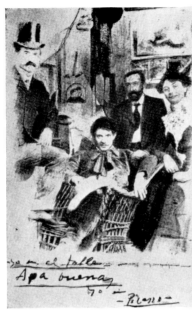

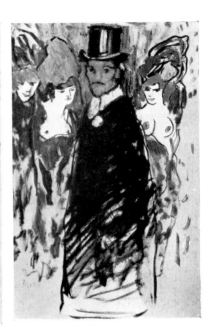

46
Picasso: *Self-portrait with Jaume
Andreu Bonsons, who travelled with
Picasso on his second visit to Paris.* 1901
(pen and coloured crayon).

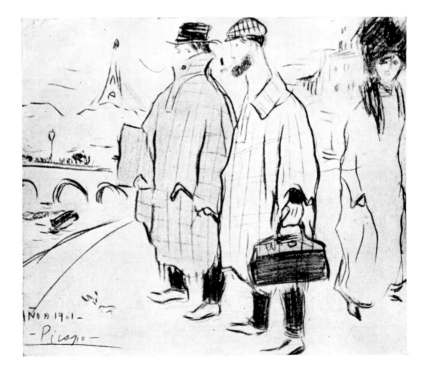

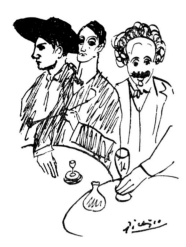

47
Picasso: *Self-portrait with Angel F.
de Soto and Sebastian Junyer-Vidal.*
1902 (pen and ink).

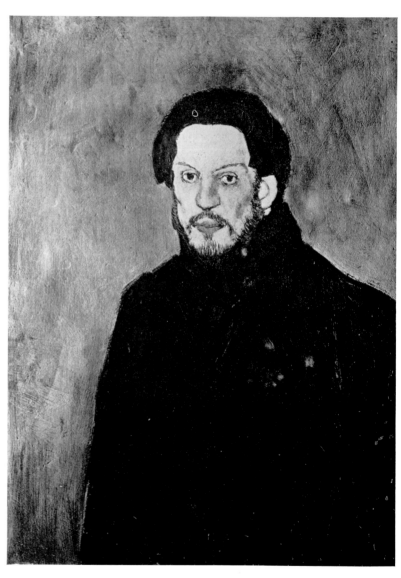

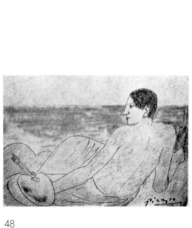

48
Picasso: *Self-portrait on beach.* 1902
(pen and coloured crayon).

49
Picasso: *Self-portrait* Paris, 1901
(oil, $31\frac{7}{8} \times 23\frac{5}{8}$). Owned by the artist.

50
Picasso: *Self-portrait with Egyptian crown*. 1901. O'Hana Gallery, London. The Douanier Rousseau is said to have told Picasso: 'We are the greatest painters of our time, you in the Egyptian style, I in the modern.'

51
Picasso: *Self-portrait*. 1902 (brush and ink). The writing at the top of the drawing is not by Picasso.

52
Picasso: *Letter to Max Jacob from Barcelona.* 1902 (pen and ink, 10½ ×8¼). Collection Gérald Cramer, Geneva. Below: The figure in front of the bull ring is a self-portrait. Left: On the reverse of the same letter is a drawing of the horses that drag the dead bull from the arena after the fight.

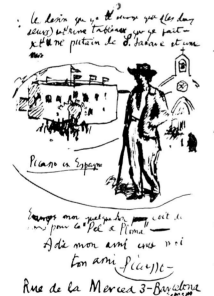

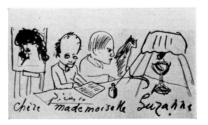

53
Picasso: *Drawing, heading a letter from Max Jacob to Mme Suzanne Bloch, wife of the musician Henri Bloch.* 1905. Left to right: portrait of Mme Bloch, Max Jacob, Picasso, and their cat.

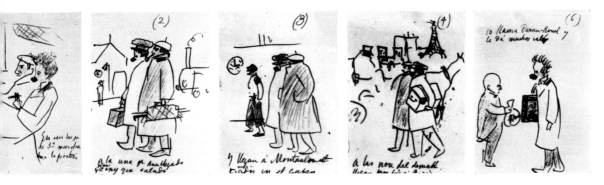

Translation of titles. (1) *They reach the frontier in a third-class carriage.* (2) *At one o'clock they have arrived and say: 'Cony, qué salado!'* (3) *They arrive at Montauban wrapped in their overcoats* (4) *And at nine, they arrive at Paris at last.* (6) *He gets to Duran-Rouel* [sic]*and he gives him a lot of cash.*

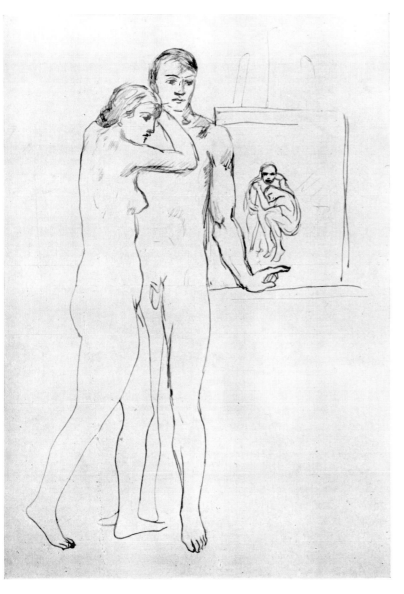

54 (above)
Picasso: *Halleluiah*. 1904.
A description in drawings of a journey to Paris in April 1904 with S. Junyer-Vidal for whom he prophesies success.

55
Picasso: *Self-portrait*. 1903
(pen and ink, $10\frac{1}{2} \times 7\frac{3}{4}$). Private collection, London. This is a sketch for the painting *La Vie*, 1903, now in the Cleveland Museum of Art.

56
Picasso in Paris, 1904, with
the inscription, *A mes chers amis
Suzanne et Henri* [*Bloch*].

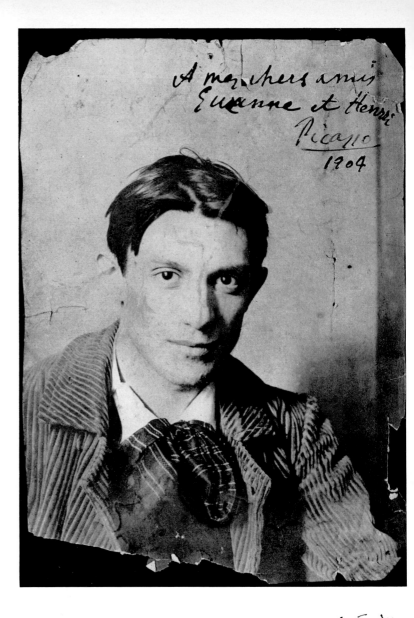

57
Windows of Picasso's studio,
'Le Bateau Lavoir'. The arrows
were drawn by Picasso. Translation
of note: 'Windows of my studio 13 rue
Ravignon'.

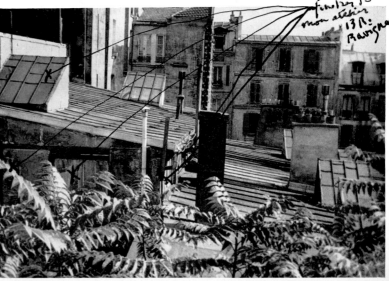

58
Picasso: *Portrait of Fernande Olivier.*
c.1906.

59
Fernande Olivier and Picasso in
Montmartre, c.1906.

60
Fernande Olivier, c.1906.

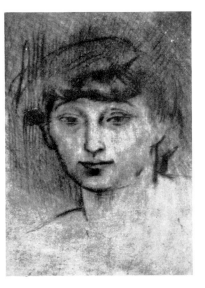

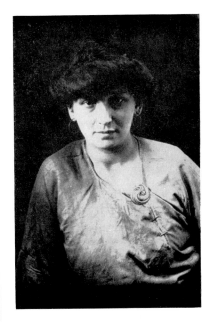

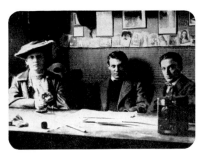

61
Picasso, Fernande Olivier, and the
writer Ramón Reventos in Barcelona.
1906. Photo by Vidal Ventosa.

62
Gertrude Stein, c.1906.
Gertrude Stein Collection,
Yale University.

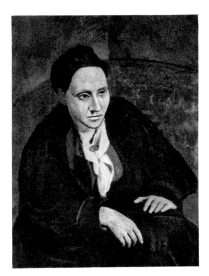

63
Picasso: *Gertrude Stein*
1906 (oil, 39 × 32).
Metropolitan Museum of Art, New York.

64
Picasso: *André Salmon*. 1907
(pen and ink).

65
André Salmon: *Portrait of Picasso*.
1908 (ink and water-colour, $8 \times 5\frac{1}{2}$).
Col. Picasso.

66
Fernande Olivier: *Portrait of Picasso*.
c.1908.

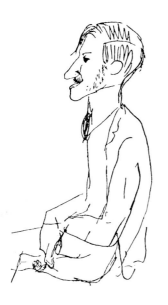

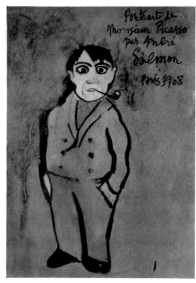

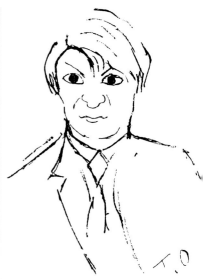

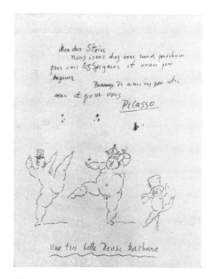

67
Picasso: *Letter to Leo Stein thanking him
for an invitation to lunch, with a drawing
of 'Une très belle danse barbare'*. 1905.

68
Derain: *Portrait of Picasso*. 1908
(ink, $8\frac{1}{4} \times 6\frac{1}{2}$) with the inscription
'*mon portrait fait par André Derain*'.
Col. Picasso.

69
Marie Laurencin: *Portrait of Picasso*.
c.1908 (oil, $16\frac{1}{4} \times 13$).

70
Picasso: *Portrait of Max Jacob*.
1907 (gouache).

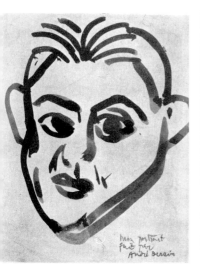

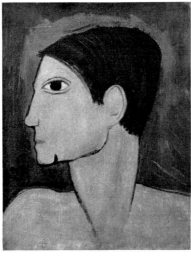

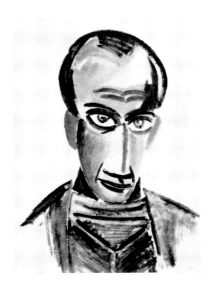

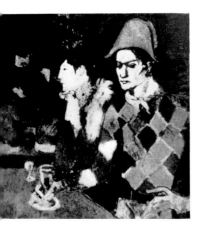

71
Picasso: *Harlequin*. 1905 (oil, $39\frac{1}{2} \times 39$).
A self-portrait of Picasso disguised as
Harlequin. He is seated beside
Germaine Pichot formerly the friend of
Casagemas at the Lapin Agile. In the
corner the patron Fredé plays the guitar.

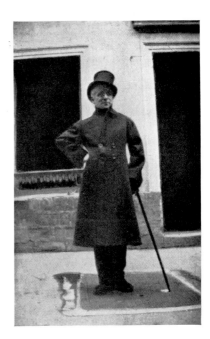

72
Max Jacob in front of his lodgings
in Montmartre, wearing the top hat
that he shared with Picasso.

Les Demoiselles d'Avignon

In the spring of 1907, Picasso showed his friends the large and astonishing canvas freshly and rapidly painted with his usual impetuosity which has since become known as *Les Demoiselles d'Avignon*. The shock to all who saw it was unforgettable. At first no one understood his purpose. He overheard Matisse and Leo Stein laughing behind his back. Braque is reported to have remarked that it was as if Picasso wished them to exchange their normal diet for one of tow and paraffin. His most devoted friends could only gape and advise him not to continue in this vein. Poets, painters, patrons, and dealers, with not more than one or two exceptions, disapproved profoundly. They regretted sadly such 'a loss to French art'.

In his solitude Picasso stood unshaken and as time went on he had the satisfaction of seeing his friends begin to realize that this picture was a landmark in the history of contemporary art. He had had the courage to risk everything and question the meaning of beauty itself. That he should be thought mad, left him indifferent, but that he should be considered dangerous, he knew was just. His change of style was profound and consistent. It is reflected in two self-portraits, one painted in 1906 and the other a year later (see Nos. 73 and 74).

The birth of a new style

The Blue Period came to an end in 1904, and with an increasing consciousness of the importance of primitive art and of Cézanne, the energy and imagination of Picasso led him through successive stages of development, now classified as the Rose and Negro Periods. It seemed incredible that he could enjoy the company of so many friends, work so long at night, sleep so late, produce such a vast quantity of work, and retain unbounded curiosity in all that went on around him.

By the autumn of 1909, Picasso had become known, both in Paris and abroad, as a young painter of exceptional talent. His earnings allowed him to move to a more spacious and comfortable studio where he had room to hang on the walls his acquisitions and gifts from his friends. Among them were Matisse's portrait of his daughter Marguerite and finds that he had made which included African masks, paintings by the Douanier Rousseau, a small Corot, also strange objects that fascinated him regardless of their value. With his friends he continued to frequent by night the circus and the gas-lit entertainments of Montmartre.

During the summer, Picasso followed the custom usual among artists of leaving Paris and choosing a quiet place in the country to work. On his return in the autumn of 1908 from a visit to La Rue

73
Picasso: *Self-portrait*. 1906 (oil, 36 × 28). Philadelphia Museum of Art.

74
Picasso: *Self-portrait*. 1907 (oil). National Gallery, Prague.

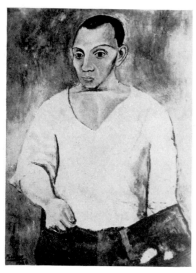

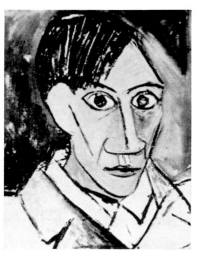

75
Picasso with a cat, 1910 or 1911.
Behind him there is a reproduction of
Ingres' *Odalisque* and a fragment of
Aubusson tapestry, and beside him a
guitar.

76
Interior of 11 Boulevard de Clichy
with the painter Pichot, 1910 or 1911.
At the top of the photograph part of
Matisse's portrait of his daughter can
be seen; below it is the first negro mask
bought by Picasso, to the left is a
landscape of Horta by Pallarés, and a
Cubist drawing by Picasso.

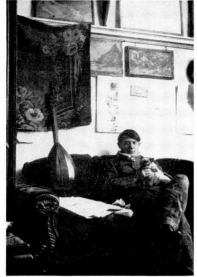

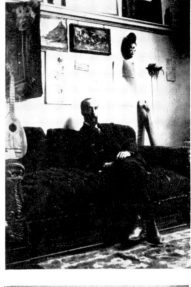

77
Picasso dressed in the uniform of
Georges Braque. 1909.

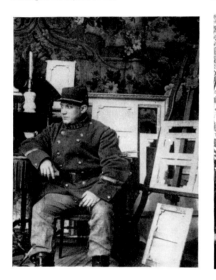

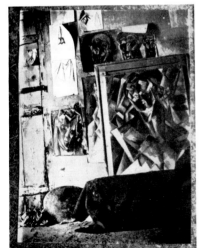

78
11 Boulevard de Clichy.
Picasso's studio from 1909–12.

79
Fernande Olivier with the niece of
Manuel Pallarés Grau at
Horta de San Juan. 1909.

80 (left)
Interior of Picasso's studio at
Horta de San Juan. 1909.

81
Maison Delcros, Céret.
Picasso stayed at this house in Céret in
the summers of 1911, 1912, 1913.
Photo by Robert Julia.

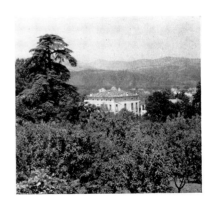

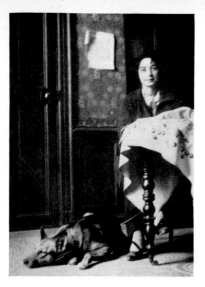

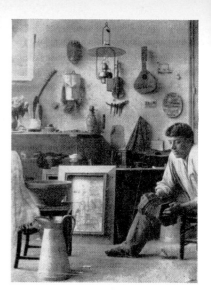

82
Eva (Marcelle Humbert) with dog at Sorgues. 1912.

83
Cubist paintings in front of La Villa les Clochettes, Sorgues. 1912.

84
Georges Braque in his studio in Montmartre. 1910.

des Bois, north of Paris, with a large quantity of landscape, still life, and figure paintings, he found that Braque had brought back from L'Estaque a series of landscapes in a similar style that earned at the Salon d'Automne, the derisive title, 'Cubist'. From then on Picasso and Braque, in spite of the difference in their temperaments, became closely associated in their work, and others, particularly Fernand Léger and Juan Gris, began to explore the possibilities of this new form of art. Without desiring it, Picasso found himself acclaimed as the founder of a new school of painting, Cubism.

Several times he returned to Spain. Of these visits, one of the most productive was the summer he spent at Horta de San Juan with Fernande. The following year he went with Derain and Pichot to Cadaqués and in 1911 his old friend Manolo persuaded him to visit Céret. A group of friends, including Braque, Max Jacob, Juan Gris, Kisling, and others were already attracted by the charm of its mountain landscape. In 1912 and 1914, two memorable summers were spent in Provence, the first at Sorgues and the second at Avignon. In both cases Braque was living nearby.

Photographs taken during these years are still scarce, and portraits are completely lacking except for the imposing paintings by Picasso of a few chosen friends in the analytical Cubist style. As a result, there are no drawings of Eva (Marcelle Humbert), who became Picasso's companion when he separated from Fernande early in 1912. Her name or her synonym, *Ma Jolie*, however, appears inscribed in many Cubist paintings. Only two photographs of Eva are known. In one she is dressed in a kimono, bought for her by Picasso in Marseilles, and in the other their dog, one of a long succession of dogs that have belonged to Picasso, sits at her feet.

Cubist portraits

Although at first sight the Cubist portraits are not easily recognizable as likenesses, Picasso required his models to sit for them at length and with the exception of the lighthearted *Portrait of Braque*, the portraits of Uhde, Vollard, and Kahnweiler are haunted by a resemblance to their sitters. There are also pre-Cubist portraits of 1909 of Clovis Sagot and Pallarés; both are remarkable likenesses in a style showing the influence of Cézanne. Its idiom is not difficult for us to understand. The portrait of Sagot was, however, thought to be unintelligible and was held up to ridicule when it was shown in London in the first Post Impressionist exhibition in the winter of 1910–11. Pallarés, Sagot, Uhde, Vollard, and Kahnweiler were all close friends of Picasso. They had in common among them that all had championed his paintings, as friends or dealers, when others had completely failed to appreciate his work and treated him as a charlatan.

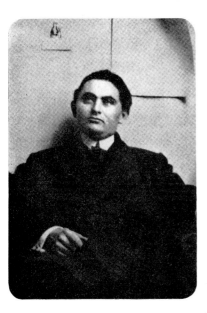

85
Photograph of D.-H. Kahnweiler taken by Picasso in his studio at 11 Boulevard de Clichy. 1912.

86
Picasso: *Portrait of Daniel-Henry Kahnweiler.* 1910, autumn (oil, $39\frac{1}{4} \times 28\frac{1}{4}$). The Art Institute of Chicago, gift of Mrs Gilbert Chapman.

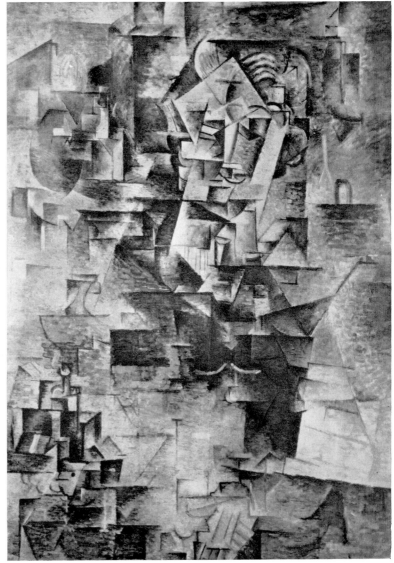

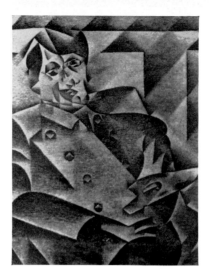

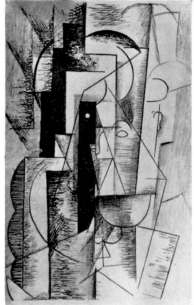

87
Juan Gris: *Portrait of Picasso*. 1912.

88
Picasso: *Portrait of Apollinaire*. 1913.
Frontispiece to *Alcools,* poems published
in Paris in 1913 (Mercure de France).

Outbreak of war in 1914

The departure of Braque from Avignon to join his regiment in August 1914 and Picasso's return later in the autumn to find that few of his friends were left in Paris, brought to an end the close association of the inventors of Cubism. Picasso has said that he never really found these friends again. He had already left Montmartre for a studio in the rue Schoelcher overlooking the Montparnasse cemetery when his sadness was increased by the death of Eva in the autumn of 1915.

Max Jacob, physically unfit for military service, was still in Paris, but the absence of Apollinaire was a serious misfortune. Although Max Jacob had never been able to follow Picasso in his Cubist discoveries and they slowly drifted apart, this did not prevent Picasso from becoming his godfather when Max Jacob became a Catholic in February 1915.

A few literary friends remained in Paris. Gertrude Stein recalls watching with Picasso the first zig-zag camouflage on guns passing along the Boulevard Raspail and quotes his remark 'We invented that'. Serge Férat and Roche Grey (Baroness Hélène d'Oettingen) who promoted the review *Les Soirées de Paris*, and later *Sic,* continued to entertain a few friends including, in the first year of the war, the painters Giorgio de Chirico and Léopold Survage.

In 1916 Picasso moved to a small suburban house in Montrouge where he continued to work, less oppressed by the wartime atmosphere of the capital.

90 (right)
Picasso: *Max Jacob*. 1915 (lead pencil,
13 × 9¾). Col. Dora Maar.

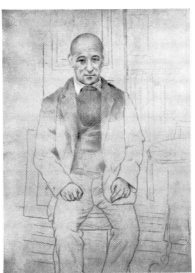

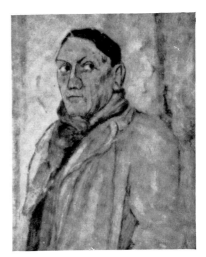

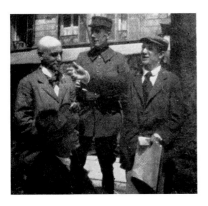

89
Picasso with Max Jacob and Henri
Pierre Roché in uniform in front of the
Café de la Rotonde, Boulevard du
Montparnasse, 1915.

91
Max Jacob: *Portrait of Picasso*.
c.1917 (oil).

92
The Imitation of Jesus Christ, given to
Max Jacob on the day of his baptism by
Picasso who became his godfather.
1915.

93
Modigliani: *Picasso*. 1915 (drawing,
10¼ × 8¾). Col. Mme Renée Laporte.

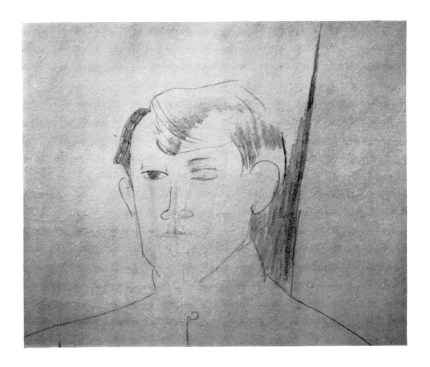

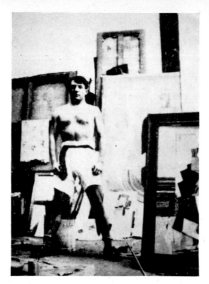 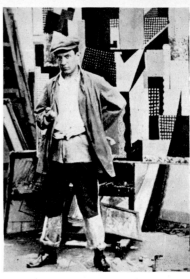

94–95
Picasso in his studio, 5 bis rue
Schoelcher. 1914 or 1915.

96
Gargallo: *Picasso*. Portrait bust
made for a keystone over a doorway of
the Del Bosque Theatre in Barcelona.
1917.

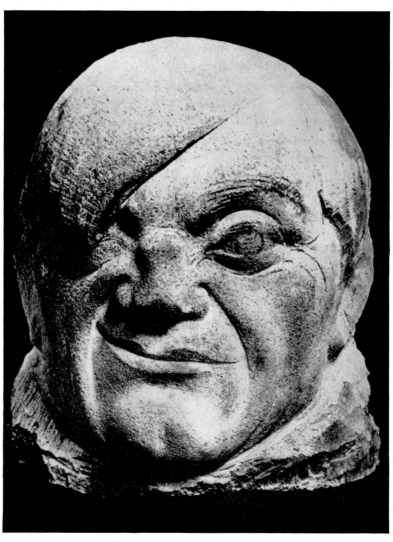

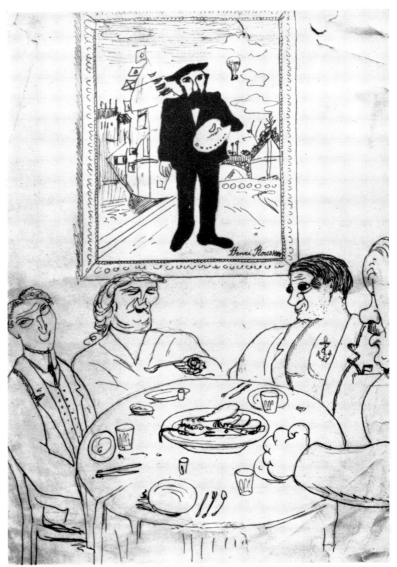

98
Picasso: *The dining room at
Montrouge.* 1917 (lead pencil).

The Russian Ballet

A diversion was brought about in the following year by the
suggestion made by Jean Cocteau that Picasso should go with him to
Rome and make designs for the scenery and costumes for Cocteau's
new ballet *Parade* for which Erik Satie had written the music. This
introduction to the Russian Ballet of Serge Diaghileff brought with
it associations with a new circle of musicians, artists, and dancers.
Stravinsky, de Falla, Bakst, and Massine were working with
Diaghileff at the time, and among the troupe was a young dancer,
Olga Koklova, with whom Picasso fell in love and married a year
later.

The war took its toll. Both Braque and Apollinaire returned with serious head wounds. In 1918, after a long convalescence, Apollinaire died unexpectedly. Only a few months before, Picasso and Vollard had been the witnesses at his wedding, and his loss was a heavy one for Picasso to bear. They had met twelve years before and Apollinaire had become the first critic to write in defence of Cubism. The genius of Picasso had inspired him both as a poet and as a critic. In one of his books, *Le Poète Assassiné*, he introduces his friend as a fantastic sculptor to whom he gives the name 'L'oiseau du Bénin' with reference to Picasso's passion for African sculpture.

99
Picasso: *Guillaume Apollinaire after he had received a head wound for which he was trepanned.* 1916 (pen and ink). He died in November 1918.

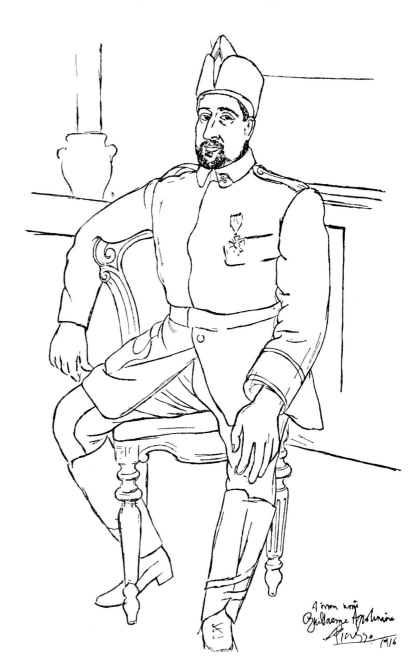

100
Picasso and Olga Koklova in Paris. 1917.

Right:
101
Picasso. 1916.
102
Picasso and Massine at Pompeii. 1917.

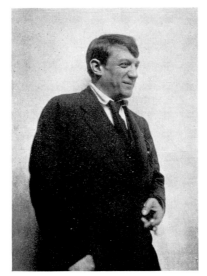

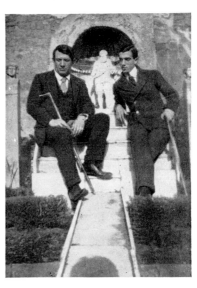

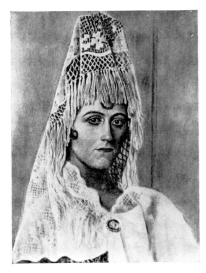

103
Picasso: *Olga Koklova in Spanish costume*. 1917 (oil).

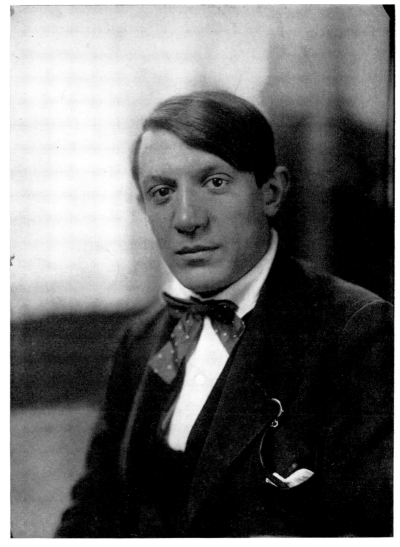

104
Picasso. 1917.

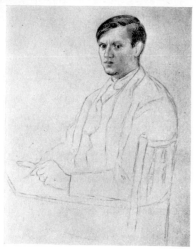

105

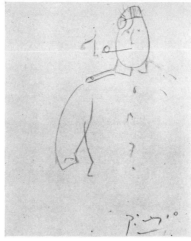

106

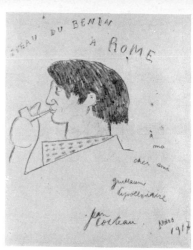

107

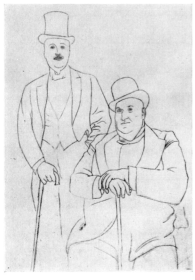

108

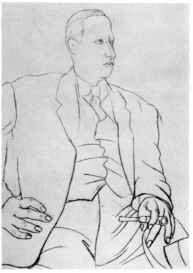

109

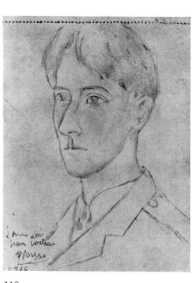

110

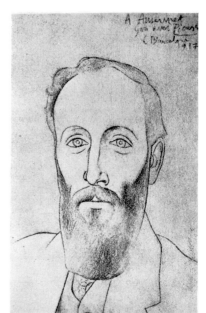

111

105
Picasso: *Self-portrait*. 1917.

106
Picasso: *Guillaume Apollinaire wounded*. 1916 (lead pencil). Col. André Lefèvre.

107
Cocteau: *Portrait of Picasso as 'L'oiseau du Bénin' dedicated to Apollinaire*. 1917 (lead pencil).

108
Picasso. *Diaghileff and Selisbourg*. 1919 (crayon).

109
Picasso: *André Derain*. London. 1919 (lead pencil). Derain designed the scenery for the ballet *La Boutique Fantasque,* first produced during the London season of 1919.

110
Picasso: *Jean Cocteau*. 1916 (lead pencil).

111
Picasso: *Ansermet, who conducted for the Russian Ballet*. Barcelona, 1917 (lead pencil).

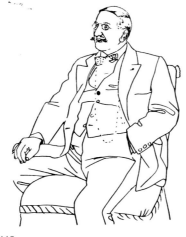

112

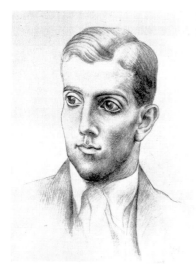

113

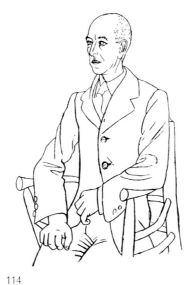

114

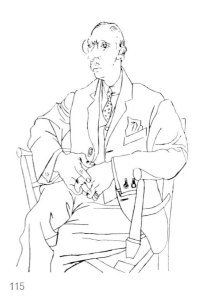

115

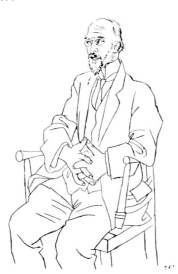

116

112
Picasso: *Léon Bakst*. 1922
(lead pencil).

113
Picasso: *Léonide Massine*.
London, 1919 (lead pencil).

114
Picasso: *Manuel de Falla*. 1920
(lead pencil).

115
Picasso: *Igor Stravinsky*. 1920
(lead pencil).

116
Picasso: *Erik Satie*. 1920 (lead pencil).

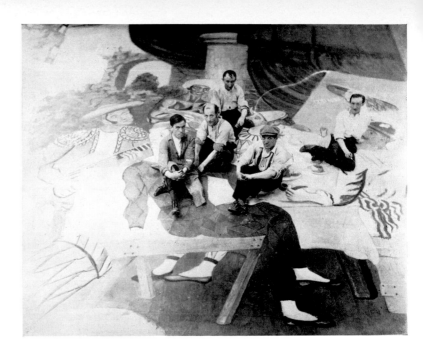

117
Picasso with scene painters sitting
on the drop curtain of *Parade*. Rome,
1917. This ballet was first produced by
Serge Diaghileff in Paris in May 1917
and in London in 1919. The scenario
was by Cocteau, music by Erik Satie,
and costumes and scenery by Picasso.

The move to the rue la Boétie

Picasso's association with the Russian Ballet brought him into
contact with the *élite* of an international circle of artists and patrons
who gave birth to the spectacular wave of creative activity following
the Armistice of 1918. He travelled with the Ballet from Rome to
Barcelona in 1917 and to London for the production of *The Three
Cornered Hat* with his scenery and costumes in 1919. For several
years he shared with the rest of the world a sense of relaxation and
enjoyed the beauty of his young wife and his first born son (Paulo).
He took a large apartment in the rue la Boétie. Next door Paul
Rosenberg, who became his dealer after the forced absence of
Kahnweiler during the war, opened his gallery. On the walls of the
new apartment hung the paintings of Renoir, Cézanne, Rousseau,
and Matisse that Picasso had acquired, and there Madame Picasso
entertained their friends.

In 1919 Picasso went to stay with Madame Errazuriz in Biarritz
and painted some murals for her in her villa. For nine years he had
been deprived of the sea which he had enjoyed from childhood.
During the following years, apart from one summer spent at
Fontainebleau, he made long visits to places on the coast such as
St Raphaël, Juan les Pins, Cap d'Antibes, Dinard, and Cannes. In
1924 he found Diaghileff and Massine with the music critic Edwin
Evans at Monte Carlo and enjoyed the brilliant entertainment
offered by Count Etienne de Beaumont both in Paris and on the
Côte d'Azur. The discipline of Cubism yielded to scenes of
arcadian delight and the splendour of stage designs for the

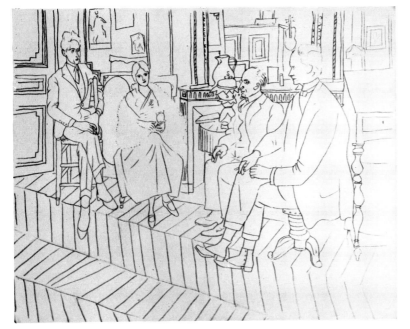

Picasso: *Cocteau, Olga Picasso, Satie, and Clive Bell at 23 rue la Boétie.* 1919 (lead pencil).

119 (above)
23 rue la Boétie, Paris. Picasso moved to this two-floor apartment in 1919 and he owned it till 1941.

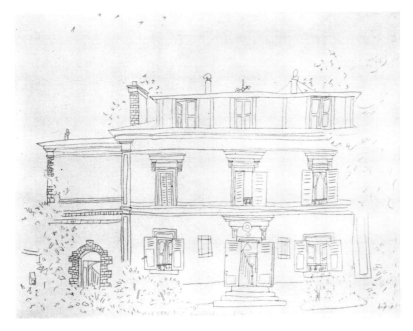

120
Picasso: *Villa at Fontainebleau where Picasso spent the summer of 1921.* (lead pencil).

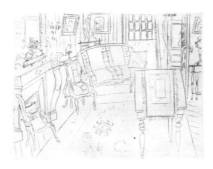

121
Picasso: *Interior of the villa at Fontainebleau.* 1921 (lead pencil).

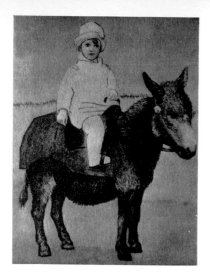

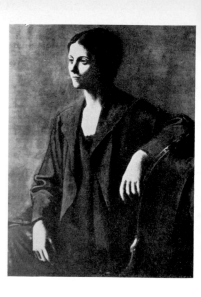

122
Picasso: *Paulo on a donkey*. 1923
(coloured drawing).
123
Picasso: *Olga Picasso*. 1923 (oil).

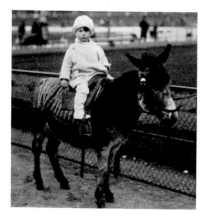

124
Paulo on a donkey. 1923.

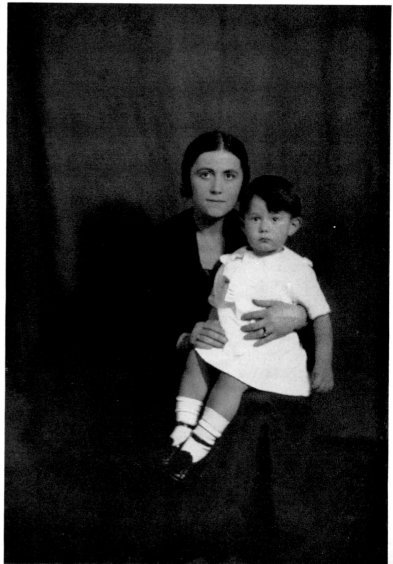

125
Olga Picasso with Paulo. 1923.
Photo by Man Ray.

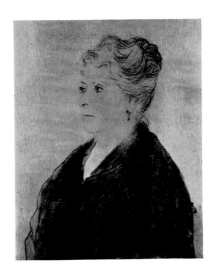

126
Picasso: *The mother of the artist.*
1923 (oil).

127
Picasso with Paulo at Juan les Pins.
1925.

ballet. In a more violent mood he painted a great composition,
The Three Dancers, in 1925 and introduced into it the profile of his
old friend Pichot whose death occurred while he was at work on this
picture.

But Picasso had not forgotten his former discoveries nor did he fail
to watch closely the rebellious 'Dada' movement led by Tristan
Tzara and take interest in its successor, Surrealism. André Breton,
Paul Eluard, Louis Aragon, Robert Desnos, Max Ernst, Joan Miró,
and Man Ray were among the talented group of poets and painters
who gave Surrealism its original impetus. But Picasso has never
found it necessary in his art to limit himself to one style or one group
of artists. His mastery of the medium allows him to use in the same
day as many styles as he finds appropriate to his need for expression.
In spite of frequent invitations, he remained aloof from group
activities.

Cubism had never been abandoned, but in 1925 Picasso's mood
became less tranquil. He began to add to his paintings an element of
violence that had not appeared in earlier work. Distortions of the
human form began to reveal that confidence was turning into doubt
and love into estrangement, a process that found its culmination in
one miserable year, 1935, when separation from his wife and
recriminations drove him for a while almost to abandon painting.
Although he painted very little, this period was marked by an
outburst of poems written in both French and Spanish.

The moment of despair was fortunately brief. A year later,
some months after the birth of his daughter Maïa, offspring of a
liaison with Marie Thérèse Walter, whose beauty had inspired the
great moonlike heads in the sculpture and paintings of the early
thirties, Picasso met Dora Maar. The years that followed were

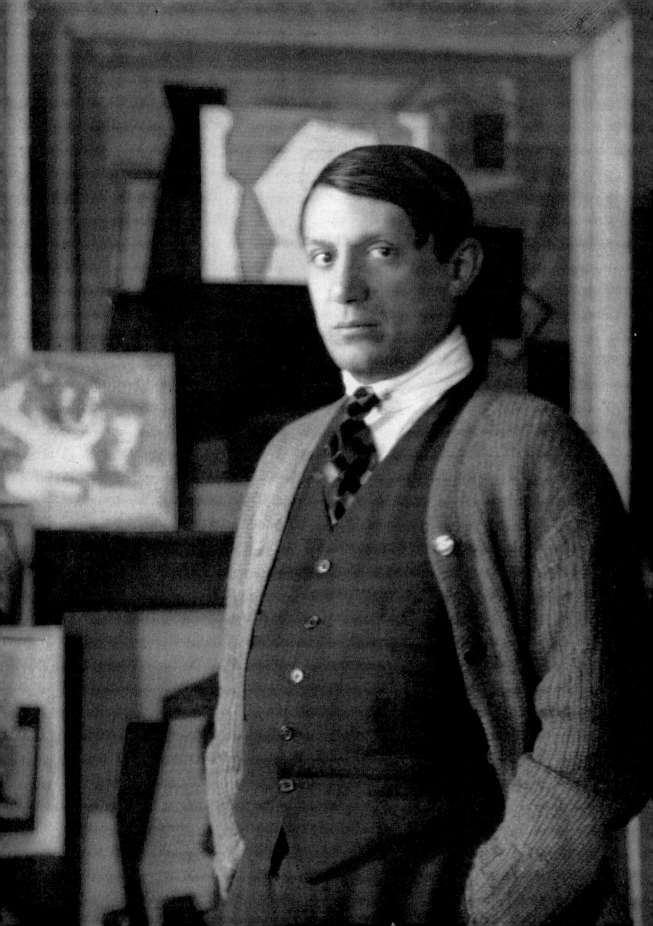

128 (left)
Picasso in his studio. 1922.
Photo by Man Ray.

129
Picasso with Mme Errazuriz and
Olga Picasso at a ball given in Paris by
the Comte Etienne de Beaumont. 1924.
Photo by Man Ray.

130
Picasso in Barcelona surrounded
by a group of friends. On his left is the
painter Iturrino with whom Picasso
shared his first exhibition at Vollard's
gallery in 1901. At the back holding his
hat is Miguel Utrillo. 1918.

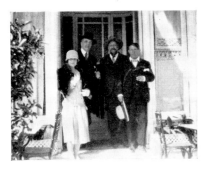

131
Olga Picasso, Diaghileff, Edwin
Evans, and Picasso at Monte Carlo.
1925.

132
Fancy-dress party on La Garoupe
beach. Antibes. 1926. On left Olga
Picasso, holding her hand is Comte
Etienne de Beaumont, and on extreme
right the Comtesse de Beaumont.
Picasso, not disguised, is seated in
the centre.

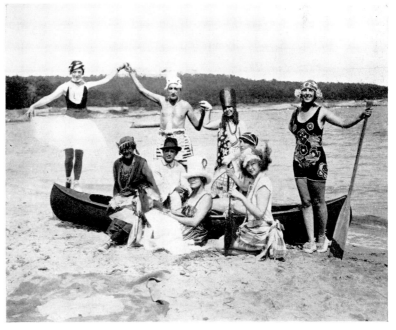

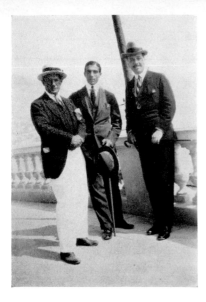

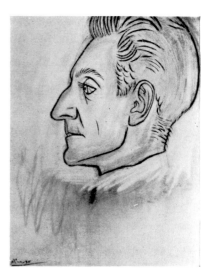

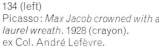

133 (far left)
Picasso, Massine, and Diaghileff at Monte Carlo. 1925.

134 (left)
Picasso: *Max Jacob crowned with a laurel wreath*. 1928 (crayon). ex Col. André Lefèvre.

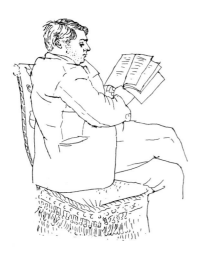

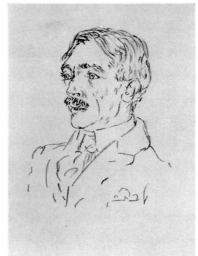

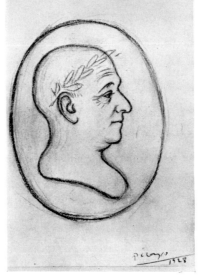

135 (above)
Picasso: *Pierre Reverdy*. 1922.
Frontispiece for *Cravates de Chanvre*, Paris (Editions Nord-Sud).
(Etching, $8\frac{3}{4} \times 6\frac{1}{4}$).
ex Col. Dr Bernhard Geiser.

136 (centre)
Picasso: *Paul Valéry*. 1921.
Frontispiece for *La Jeune Parque*, Paris.
(N.R.F.). (Lithograph, $7\frac{1}{8} \times 5\frac{1}{8}$.)
ex Col. Dr Bernhard Geiser.

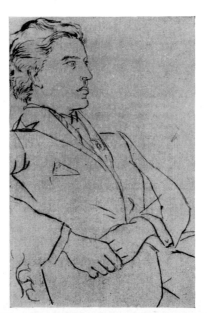

137 (above)
Picasso: *Comte Etienne de Beaumont, the animator of les Soirées de Paris*. 1925 (lead pencil and rubber).

138
Picasso: *André Breton*. 1923.
Frontispiece for *Clair de Terre*, Paris (dry point, $11 \times 7\frac{1}{2}$).
ex Col. Dr Bernhard Geiser.

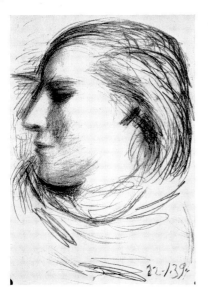

139
Picasso: *Marie Thérèse Walter.*
1939 (crayon).

fertile in inspiration. The bull fight with which he had been familiar from his early youth in Spain and its associated legends and myths, became once more vivid in his thought, forming the background of themes in which the Minotaur was at the same time hero, monster and victim, replacing in a more brutal and ambiguous form the image of himself that he had found more than twenty years before in Harlequin.

Boisgeloup, rue des Grands Augustins and Spain

In 1932 Picasso established himself in Normandy at the seventeenth-century Château de Boisgeloup, graceful in its proportions and surrounded by noble trees. Across the courtyard there were extensive stables which he used as studios for the heads he was sculpting inspired by Marie Thérèse. Four years later he added to his overcrowded studio apartment in Paris the great rooms of the former Hôtel des Ducs de Savoie in the rue des Grands Augustins. It was there that he found sufficient space to work on the vast canvas of *Guernica*.

In 1933 and again in the following year Picasso revisited Spain. The first trip took him only to Barcelona where his mother and his sister Lola, now married to Dr Vilató, were still living. The next visit took him to San Sebastian, Madrid, Toledo, and the Escurial. For the first time in twenty-five years a group of young admirers organized in 1936 an exhibition of important paintings in Barcelona which was opened by Paul Eluard. It travelled later to Bilbao and Madrid.

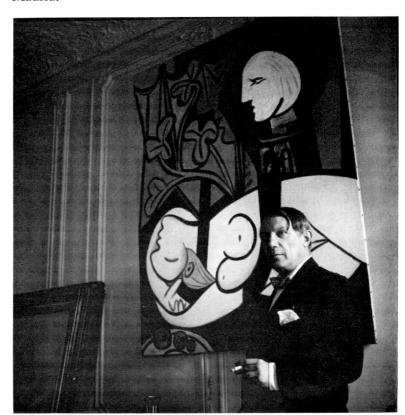

140
Picasso at 23 rue la Boétie. 1931.
On the wall is a recent picture by him.
Near the top appears the head in
profile of Marie Thérèse Walter.
Photo by Cecil Beaton.

141
Picasso at Juan les Pins. 1926.
Photo by Man Ray.

142
Picasso at 23 rue la Boétie. 1931. His
left hand rests on the head of the *Jester*,
a bronze of 1905. On his right is a
Cubist painting of 1914 and a recent
sculpture in iron on which he had hung
objects for his amusement.
Photo by Cecil Beaton.

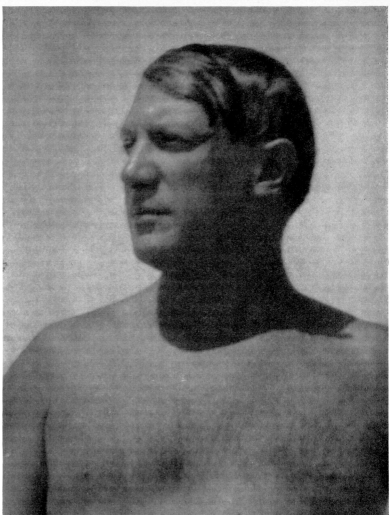

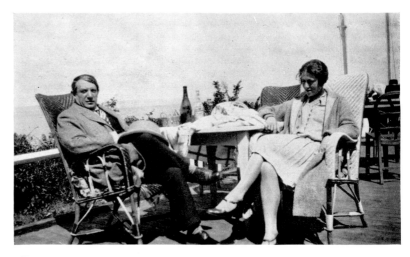

143
Picasso and Olga Picasso. Cannes.
1933.

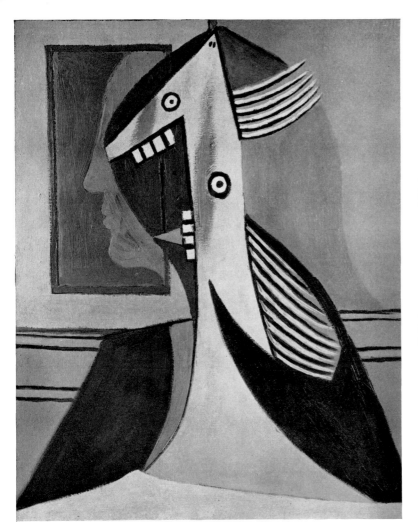

144
Picasso. *Self-portrait with a monster*.
1929 (oil, 24 × 29).

145
Château de Boisgeloup, Gisors
(Eure) bought by Picasso in 1932.

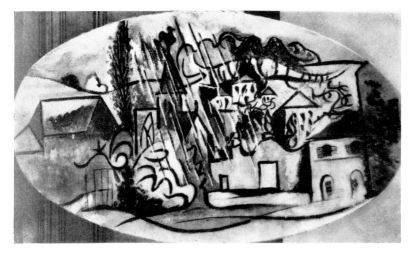

146
Picasso: *Boisgeloup in the rain*.
1931 (oil).

147
The chapel and entrance to the
château. These features appear in
several landscapes.

148
Picasso with the painter Elie
Lascaux, D.-H. Kahnweiler, and
Michel Leiris at Boisgeloup. 1932.

149
Picasso at Boisgeloup. 1932. On
his left Braque, Mme Braque, and his
son Paulo.

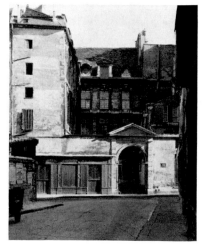

150
7 rue des Grands Augustins, Paris.
In 1937 Picasso took the two top floors
of this seventeenth-century house.
During the war he moved his living
quarters there from the rue la Boétie.

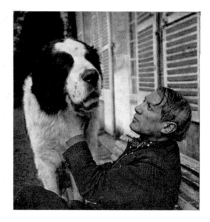

151
Picasso with his St Bernard dog at
Boisgeloup. 1935.
Photo by Dora Maar.

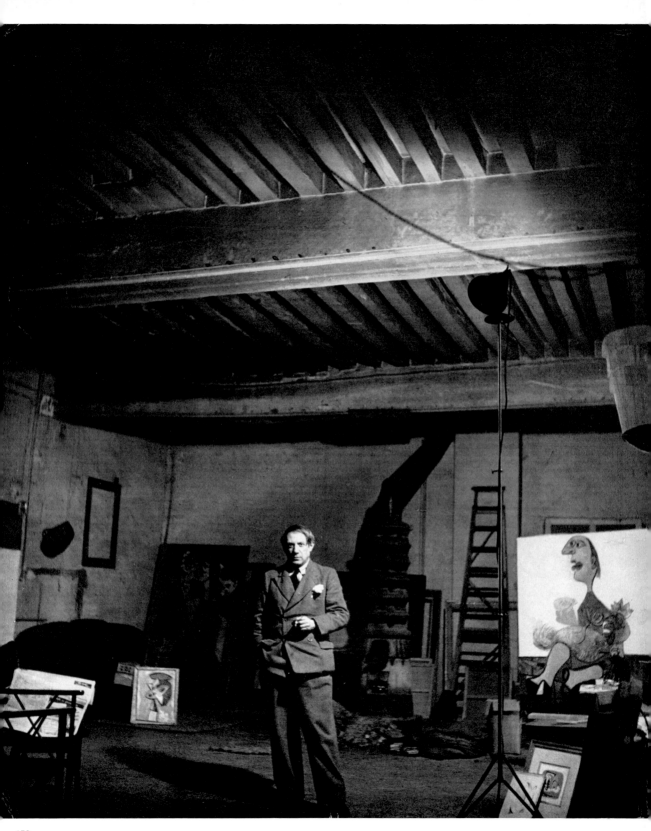

152
Picasso in his studio, 7 rue des
Grands Augustins. 1938. Where in 1937
he painted *Guernica*.
Photo by Peter Rose Pulham.

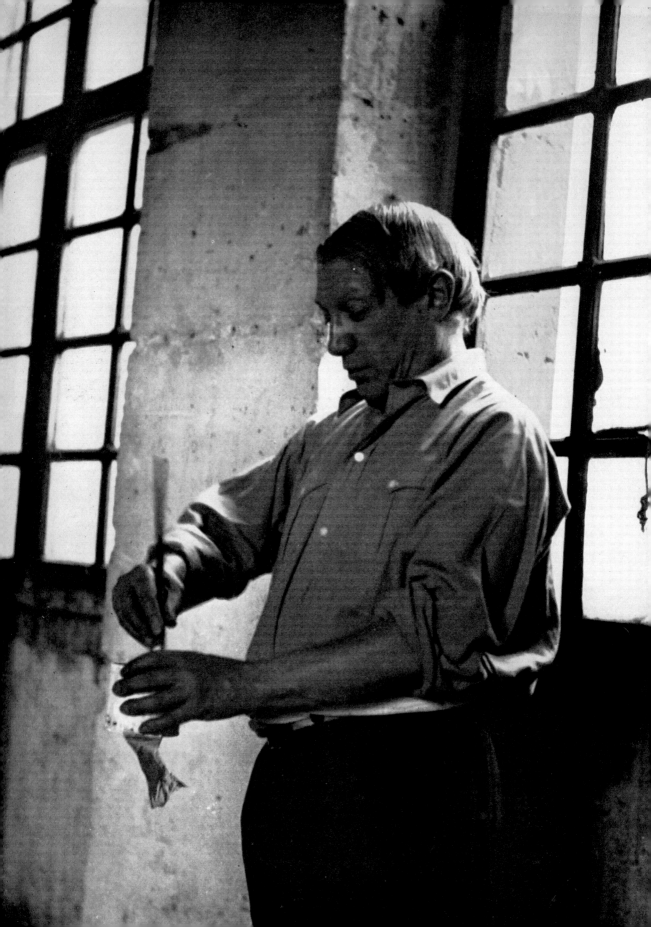

153 (left)
Picasso at work on *Guernica* mixes
his paint. 1937. Photo by Dora Maar.

154
Opening of the Guernica Exhibition
in aid of Spanish relief at Whitechapel
by the Rt Hon. Major Attlee. 1938.

155
Picasso painting *Guernica*. 1937.
Photo by Dora Maar.

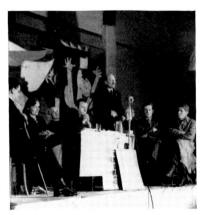

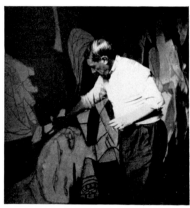

Guernica

As a Spaniard and as an artist, the outbreak of the Spanish Civil
War affected Picasso in the roots of his being. He at once made it
clear that his sympathies lay with the Republicans by accepting the
honorary directorship of the Prado. Stirred to anger by the bombing
of Guernica, he composed a great painting for the Spanish
Republican Pavilion in the Paris Exhibition of 1937. The picture
with all the preliminary sketches was exhibited in London and in
Manchester in 1938, and now hangs in the Museum of Modern Art
in New York, where it has joined that earlier painting whose
revolutionary significance is limited to the aesthetic plane, *Les
Demoiselles d'Avignon*.

156
Picasso: *Two drawings of the left
hand of the artist*. 1919 (lead pencil).

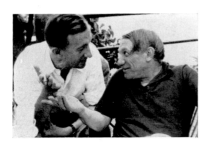

157
Picasso and Paul Eluard at Mougins.
1936. Photo by the author.

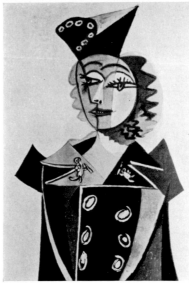

158
Picasso: *Nusch Eluard*. 1937 (oil).
Owned by the artist.

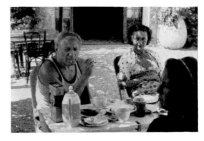

159
Picasso, Nusch, wife of Paul Eluard,
and Dora Maar, Mougins. 1936.
Photo by the author.

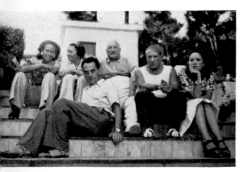

160
A group at the villa of Sénateur
Cuttoli, Cap d'Antibes, 1937. From
left to right, foreground, Man Ray,
Picasso, Dora Maar; above, a friend,
Madame Cuttoli and Sénateur Cuttoli.
Photo by Man Ray.

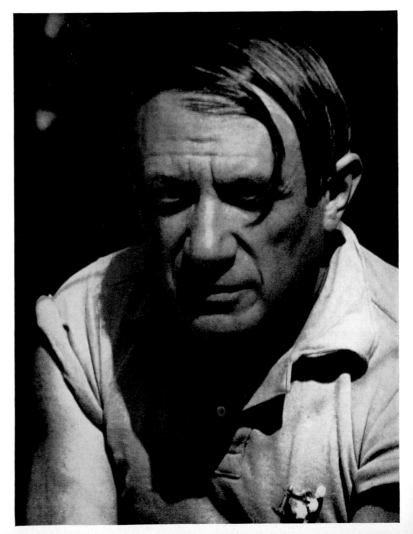

161
Picasso at Mougins. 1935 or 1936.
Photo by Man Ray.

162
Picasso with his dog Kasbec,
Golfe Juan. 1937. Photo by Man Ray.

163
Picasso and Dora Maar bathing at
Golfe Juan. 1937. Photo by R. P.

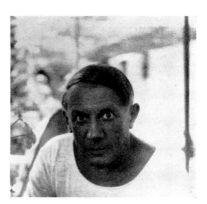

164
Picasso at Mougins. 1938.

Summer in the South of France

The summers of 1936 to 1938 were spent at Mougins. The close
friendship between Picasso and Paul Eluard coincided at this time
with Picasso's urge to write poetry and his increasing consciousness,
stirred by the Spanish war, of social and political issues. Books,
poems, and lithographs of illuminated poems were the outcome of
months spent together and Nusch, the fragile and beautiful wife of
Eluard, was the inspiration of many portraits, both lifelike and
fantastic.

165
Picasso leaving Mougins. 1937.
Photo by Man Ray.

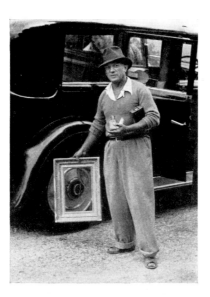

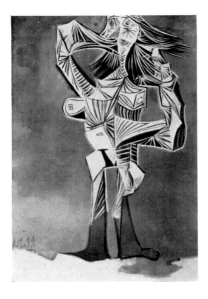 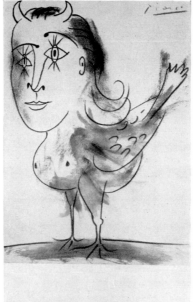 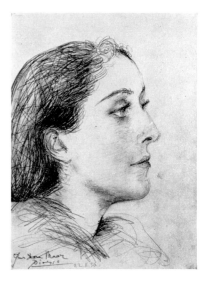

166 (above)
Picasso: *Portrait of D. M.* 1939
(gouache, $18\frac{1}{4} \times 15$).
ex Col. André Lefèvre.

167 (centre)
Picasso: *Portrait of D. M. as a bird.*
1939 ($12\frac{1}{4} \times 9\frac{1}{2}$).
Galerie Berggruen, Paris.

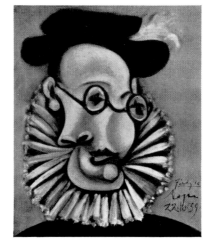

168
Picasso: *Portrait of Dora Maar.*
1944 (lead pencil, $16\frac{1}{2} \times 12$), signed
and dated later. Col. Dora Maar.

169
Picasso: *Portrait of Jaime Sabartés.*
1939 (oil, $23\frac{3}{4} \times 18$). Museo Picasso,
Barcelona.

170
Picasso: *Self-portrait from MS. of
'Desire Caught by the Tail', a play by
Picasso.* 1943. A reading directed by
Albert Camus was given in 1944. Simone
de Beauvoir, Valentine Hugo, Louise
and Michel Leiris, Pierre Reverdy,
Jean-Paul Sartre, and other friends
took part.

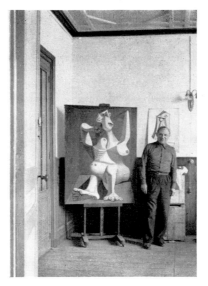

171
Picasso in his studio at Royan.
1940. Photographed by Dora Maar.
Later during the occupation the
taking of pictures was forbidden.

172
Picasso's studio at Royan. 1940.

The Second World War

When war broke out in 1939, Picasso was staying at Antibes with
Dora Maar and Sabartés. During a short visit to Paris he stored
away his work in places relatively safer than his studio and then
retired to Royan on the coast north of Bordeaux where he remained
until October of the following year. From then on he spent the rest
of the war in occupied Paris. He ignored the bribes offered by the
Germans and became absorbed in the many branches of his work,
painting, engraving, lithography, and sculpture. He also wrote
poems and a play, *Desire Caught by the Tail*, which was given a
reading in secret by a distinguished company of his literary friends
in the apartment of Michel Leiris.

While the first world war had no traceable influence on the work
of Picasso, the second, beginning with the Spanish Civil War, left
an indelible impression. Its privations, butchery and inhumanity
dominated the atmosphere. The human form was distorted with
fury. The flayed head of the bull, the cat destroying a bird, the
skull, the candle, imposed themselves as appropriate subjects.

With the increasing difficulties of living in occupied Paris,
Picasso abandoned the rue la Boétie and settled in to the less
comfortable but more spacious rooms of the rue des Grands Augustins.
During the winter months the cold made it extremely difficult to
continue to work. But Picasso remained the staunch supporter of his
French and Spanish friends, helping them in their clandestine
projects and becoming the symbol of their hopes.

Liberation

With liberation came the return of many friends from hiding and from abroad. For a while the studio in the rue des Grands Augustins was invaded by those who wished to express their delight in finding that Picasso had not only survived but that his creative vigour was unimpaired.

At this time his sense of humanity and his desire to change the existing injustice of society prompted him to join the French Communist Party and to attend congresses for peace in Paris, Rome, Warsaw, and Sheffield. In the profound hope that his presence might prove to be a factor in helping to abolish future wars, he took part frequently in such demonstrations. His drawings of the dove appeared as posters on the walls of many cities, acclaimed by some as a time-honoured symbol of peace and sneered at by others as an inept form of Communist propaganda, but there is no doubt about the disinterested motives of their author.

173
Picasso at a window of his studio with paintings. 1944.
Photo by Lee Miller.

174
In Picasso's studio, left to right: Paul Eluard, the author, Elsa Triolet, Picasso, Nusch Eluard, Louis Aragon. September, 1944.
Photo by Lee Miller.

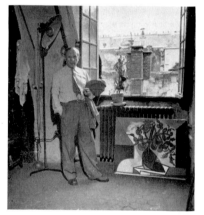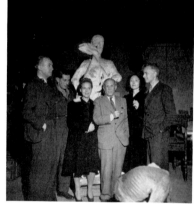

175
Picasso at rue des Grands Augustins with Lee Miller, first Allied correspondent to call on him after the liberation of Paris. 1944.
Photo by Lee Miller.

176
During the war Picasso had long discussions in his studio with painters. Here he talks with Balthus. In the background is *La Sérénade* now in the Musée d'Art Moderne in Paris. 1944.
Photo by Cecil Beaton.

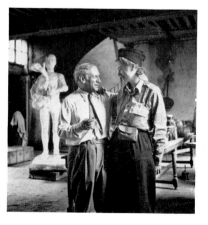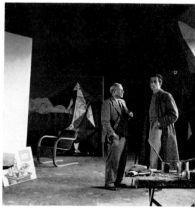

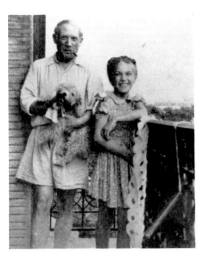
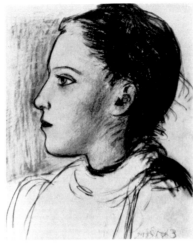

177
Picasso with his daughter Maïa on Liberation Day. Paris. 26 August 1944.

178
Picasso: *Maia*. 1944 (drawing).

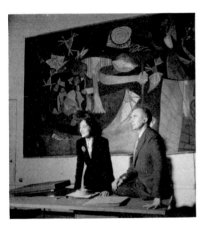
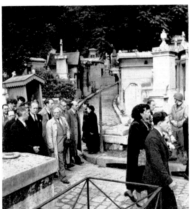

179
Paul and Nusch Eluard in front of *Les Pêcheurs d'Antibes,* painted by Picasso in 1939. In this painting, now in the Museum of Modern Art, New York, the towers of the Palais Grimaldi appear in the top left corner (see No. 188). 1944. Photo by Lee Miller.

180
Procession in the Père Lachaise cemetery, Paris, in honour of those who died in the Resistance Movement. In the centre is Picasso. On his right Paul Eluard. 2 November 1944.

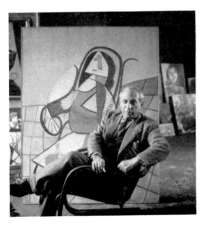
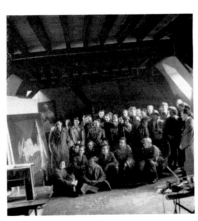

181
Picasso in his studio, rue des Grands Augustins. 1944.
Photo by Cecil Beaton.

182
Picasso receiving a visit from American Service personnel. 1944.
Photo by Cecil Beaton.

183
Picasso and Marcel Cachin, doyen
of the French Communist Party at
'La Galloise', Vallauris. 1948. Picasso
joined the Communist Party in 1944.
He settled at the Villa 'La Galloise' in
1948. Photo by André Villers.

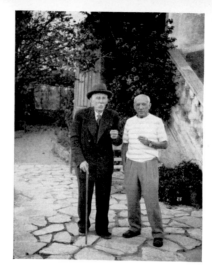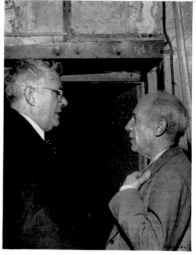

184
Picasso with the painter Guttuso
at the Peace Congress in Rome.
22 April 1949.

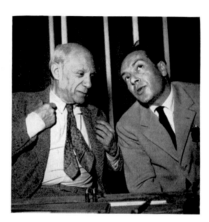

185 (above)
Picasso with Dr Evatt, President
of U.N.O., at the rue des Grands
Augustins during the exhibition of
Picasso's ceramics at the Maison de la
Pensée Française. 1949.

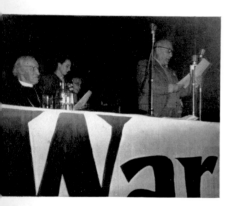

186
Picasso addressing the Sheffield
Peace Congress. 1950.

187
Picasso arriving at Sheffield with
the French Deputy Gilbert Chambrun.
13 November 1950.

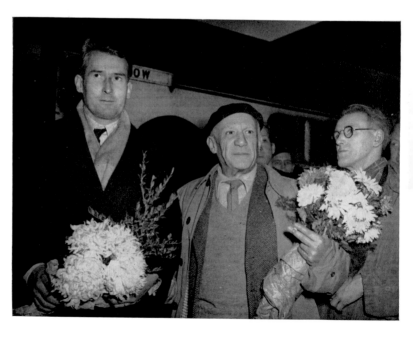

Antibes and Vallauris

When travel to the South of France again became possible, Picasso started work with new exhilaration in the ancient Palais Grimaldi at Antibes on great luminous paintings. Again a sense of arcadian abandon inherited from the Mediterranean surroundings was reflected in his work.

It was at this period that his second son and second daughter, Claude and Paloma, were born. They are the children of Françoise Gilot, whose beauty and talent had drawn Picasso to her in Paris soon after the liberation.

Visits to Paris became increasingly rare and the great seventeenth-century rooms with their oak beams and tiled floors awaited his return until they were finally reclaimed as offices in 1967.

From Antibes it is only a short distance to Vallauris. In this little town, noted since the Romans for its potteries, Picasso was attracted by the skill of the local craftsmen. Trying his hand at their trade, he began at once to revolutionize their conception of ceramics and by so doing resurrected the waning fortunes of their community. He acquired at random a small and undistinguished villa, *La Galloise*. From there his vast production soon invaded the nearby hangars of a disused scent factory. Sculpture and painting, including the great murals of *War and Peace*, designed for the vault of a deconsecrated chapel in the town, rapidly filled their space.

188
Le Palais Grimaldi, Antibes. In 1946 Picasso was loaned the spacious rooms of the Grimaldi Palace for his studio. He worked there painting the large panels that still hang on its walls now that the building is reinstated and has become a Picasso museum.

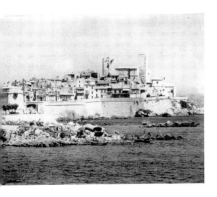

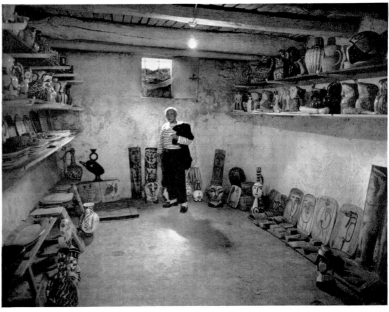

189
Picasso among his ceramics at the Madura pottery. 1952.
Photo by Robert Doisneau.

190
Interior of 'La Galloise', Vallauris. 1953.
Photo by Alexander Liberman.

191
Picasso and Claude on the beach at
Golfe Juan. 1948.
Photo by Robert Capa.

Vallauris has honoured his presence by making Picasso an honorary citizen and erecting his bronze statue of *L'homme au mouton* in a square in the centre of the town. A festival for the sale of local pottery and ceramics became an annual event and Picasso presided at bull fights attended by large numbers of his friends. These varied and continuous activities did not prevent visits to Paris and an unimpeded flow of a great variety of work including sculpture, lithography, engraving, and even the writing of poems and plays.

Although, as Sabartés remarks, the life of Picasso is usually a matter of great regularity, his unexpected decisions to visit friends living at a considerable distance or attend a bull fight could at any moment break into the normal routine of his life. Such events as the marriage of Paul Eluard at St Tropez in 1949 were brief interludes but they could entice him to linger and enjoy the pleasures of the beach and the company of his friends. In the years after the war when Matisse was confined to his bed in Nice, Picasso paid him frequent visits. Jacques Prévert, Jean Cocteau, and other friends scattered along the coast welcomed him often as an unexpected guest.

Visits from those who live nearby or who come from great distances are still frequent. His old friends sometimes are given the surprise on arrival of a display of disguises which mockingly he

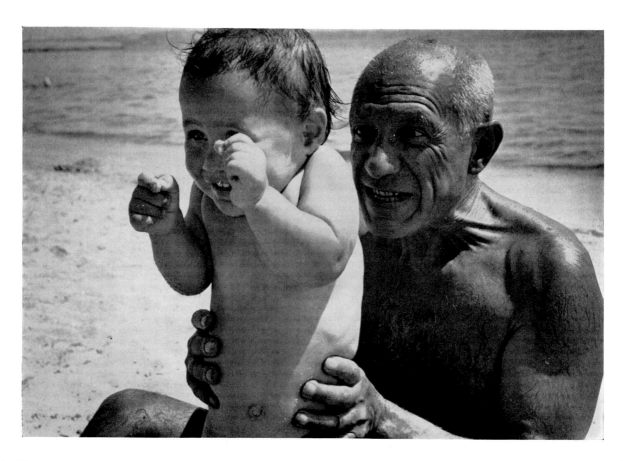

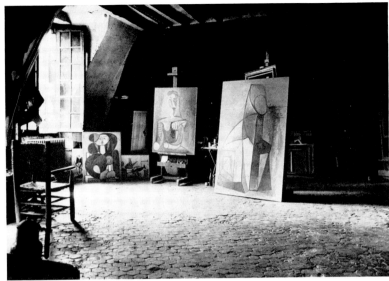

192
Work table used as a palette in the
rue des Grands Augustins, Paris, 1954.
Photo by Alexander Liberman.

193
The upper studio in the rue des Grands
Augustins, Paris in 1954.
Photo by Alexander Liberman.

puts on for their amusement. They never leave without being
astonished once more at the vigour and invention of his untiring
labours. Picasso himself brings out his canvases of all sizes and great
variety. He piles them on each other until his visitors are exhausted
by their abundance. When they have left he again starts to work
until late into the night.

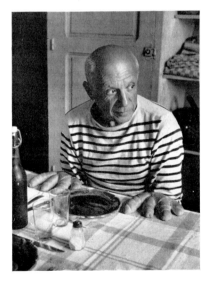

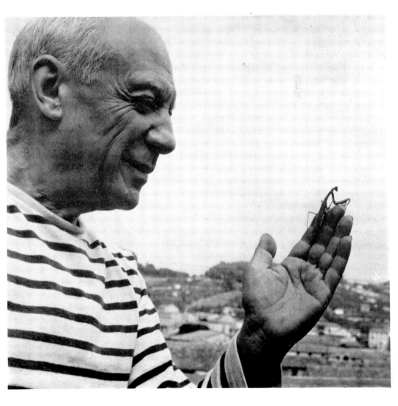

194
Picasso waits for lunch.
The rolls on the table are baked in Val-
lauris and known as 'Picasso's hands'.
1952. Photo by Robert Doisneau.

195
Picasso examines a praying mantis.
1952. Photo by Robert Doisneau.

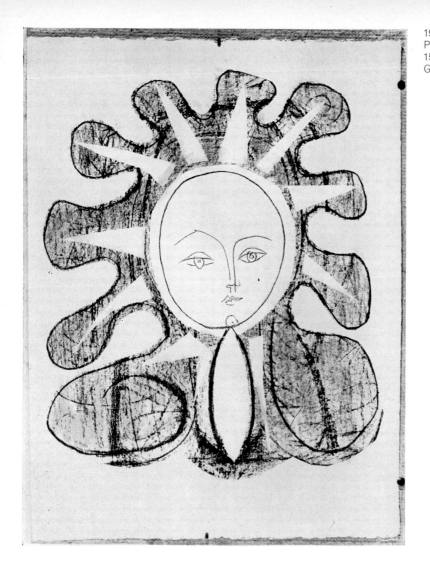

196
Picasso: *Françoise en Soleil.*
15 June 1946 (lithograph, 21 ×17¾).
Galerie Louise Leiris, Paris.

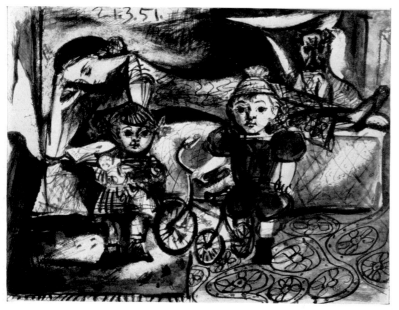

197
Picasso: *Claude and Paloma, son and daughter of Picasso, with their mother, Françoise Gilot.* 1951 (9 ×12½).
Col. Claude Gilot Picasso.

198 (right)
Françoise Gilot under an umbrella, Picasso, and Javier Vilató, his nephew, at Golfe Juan. 1948.
Photo by Robert Capa.

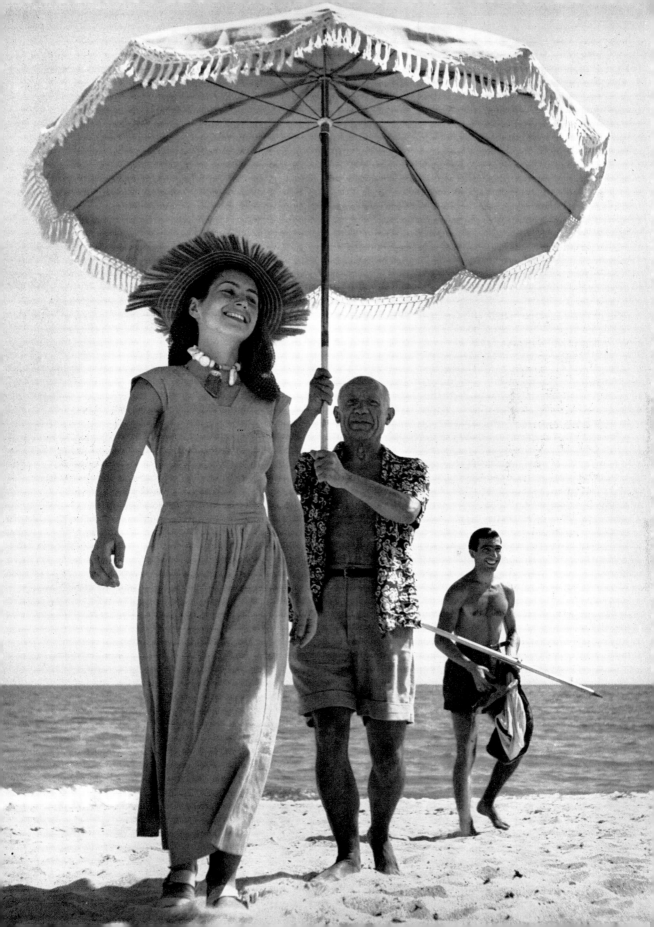

199
Picasso and Joan Miró at Vallauris.
1951.

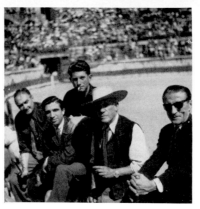

200
Picasso in the arena at Nîmes with
left to right: Lacourière, Javier Vilató
(nephew), Paul Picasso, Picasso,
Castel. 1952.

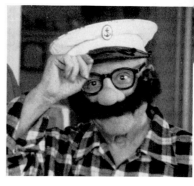

201
Picasso dresses up to welcome his
friends. Cannes. 1956.

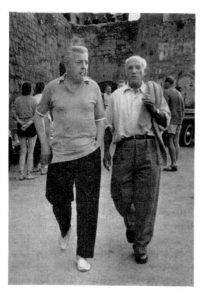

202
Picasso visits Jacques Prévert at
St Paul-de-Vence. 1953.

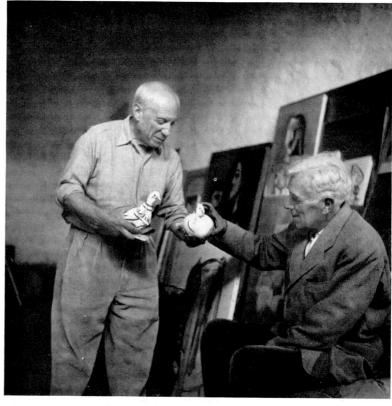

203
Braque visits Picasso in his studio
at Vallauris. 1954. Photo by Lee Miller.

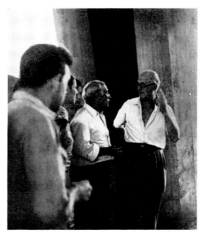

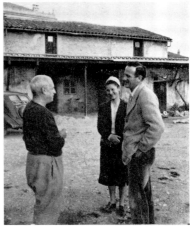

204
Le Corbusier shows Picasso
round the 'Unité d'Habitation' at
Marseilles. 1949.

205
Picasso with Graham and Katherine
Sutherland at Vallauris. 1951.

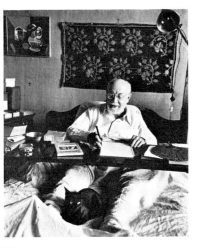

206
Matisse confined to his bed, but
at work. On the left hangs a painting
given to him by Picasso. Nice. 1948.
Photo by Robert Capa.

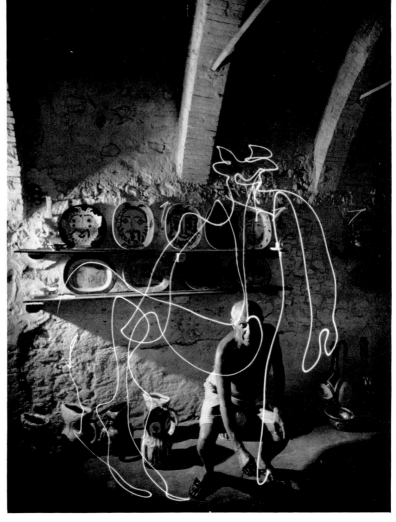

207
Picasso drawing with a flash-light.
Vallauris. 1949. Photo by Gjon Mili.

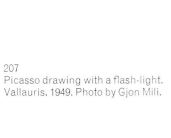

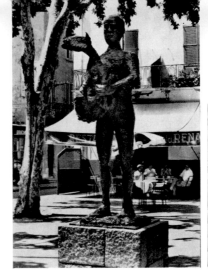

208
Picasso: *L'homme au mouton*.
1943–4 (bronze).

209
Unveiling of the statue of *L'homme au mouton* at Vallauris. 1951. The Deputy Casanova addresses the gathering, to his right are the mayor of Vallauris and Tristan Tzara, to his left Picasso and Paul Eluard.

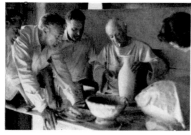

210
Picasso with Gary Cooper and the master potter Aga at the Madura pottery at Vallauris. 1956.
Photo by Lee Miller.

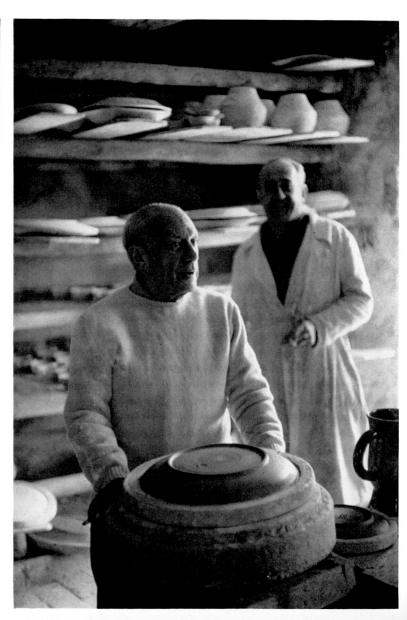

211
Picasso at the Madura pottery with Georges Ramié the director. 1950.
Photo by Henri Cartier Bresson.

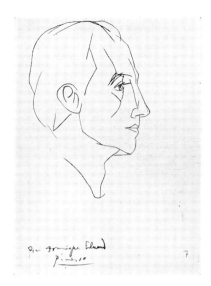

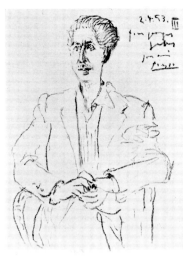

212
Picasso: *Paul Eluard* (No. 7 of fourteen
portraits). 1951 (lead pencil).
Col. Mme Eluard.

213
Picasso: *Georges Salles*. April 1953.
A close friend and for many
years director of the Louvre.

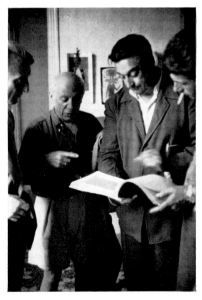

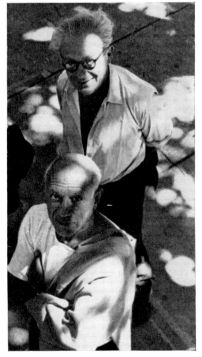

214
Picasso examines a book with,
on his right, the publisher Albert Skira,
and on his left a Spanish bullfighter,
and his son Paul. Vallauris. 1953.
Photo by Alexander Liberman.

215
Tristan Tzara and Picasso at Vallauris.
1951.

216
Wedding of Paul and Dominique
Eluard. Picasso and Françoise Gilot
were witnesses. St Tropez. 14 June 1951.
Photo by Lee Miller.

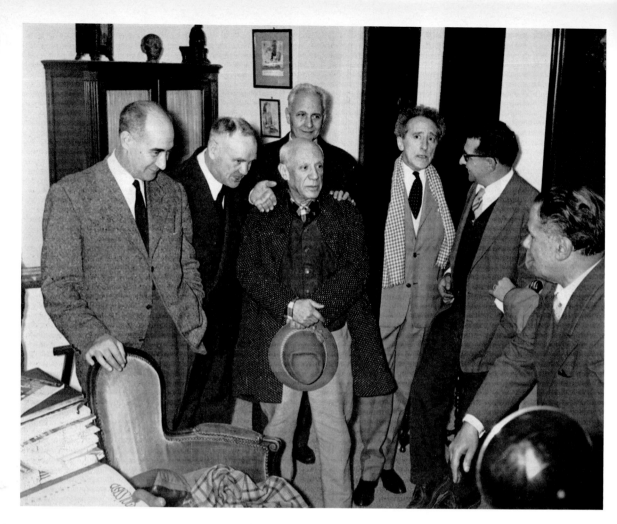

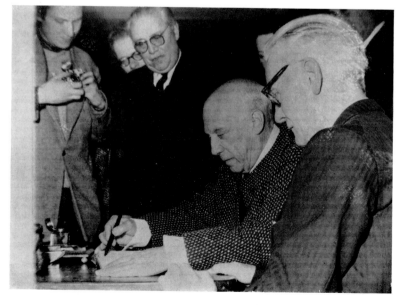

218
The citizenship of Antibes is conferred on Picasso. With him at the ceremony are his friends Madame Cuttoli and Georges Salles, director of the Louvre. February 1957. Photo Nocenti.

219 (right)
Picasso signs in the presence of M. Pugnaire, the mayor of Antibes, and M. Dor de la Souchère, Director of the Musée Picasso (right). February 1957.

217 (left)
Picasso is welcomed at the opening of
an exhibition organized by
H. Matarasso in his gallery in Nice by
(left to right) the communist politicians
Casanova and Maurice Thorez, Louis
Aragon (behind Picasso), Jean Cocteau,
Tabaraud, editor of *Nice Soir*, and
H. Matarasso. 1956.
Photo by André Villers.

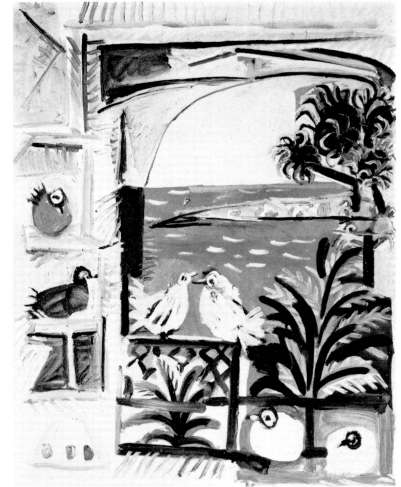

220
Picasso: *Doves at La Californie* 12.9.'57.
In the embrasure of the window looking
out over the Ile Ste. Marguerite on the
top floor of 'La Californie' Picasso made
a dovecote. It was in this room that he
painted the Meninas variations, now in
the Museo Picasso, Barcelona, by
night, and views such as this by day.

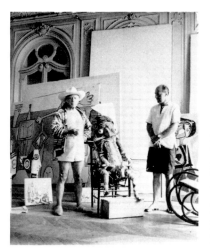

221
Picasso receives from Pierre Matisse
a figure from the New Hebrides that
his father, Henri Matisse, before he
died, had given to Picasso. 1957.
Photo by André Villers.

222
The great mural for the new UNESCO
building in Paris shown for the first time
at a school in Vallauris after being
unveiled by Georges Salles. 1958.
Photo by André Villers.

La Californie, Cannes

After his separation from Françoise Gilot, Picasso moved to a
commodious villa overlooking Cannes, surrounded by palms and
eucalyptus trees. It was empty when he arrived, in the spring of
1955, but its spacious well-lit drawing rooms which became his
studio were rapidly crowded with new paintings which combined the
many styles and discoveries of a lifetime. In addition to this incredible
production, he spent the summer of the same year working on
the full length film *Le Mystère Picasso* produced by Henri-Georges
Clouzot, in which he was the sole performer.

The major factor that brought relaxation and delight to
Picasso in the move to La Californie was the presence of Jacqueline
Roque. Her classical profile and her large tranquil eyes became
the dominant theme in the paintings that rapidly began to fill the
drawing rooms, all of which were used as studios, while in the
wine cellars below, Picasso installed presses for his engravings and
lithographs.

For Picasso, his friends, and above all his loves, are the sources
of his inspiration even more than the objects and the landscape
around him. They continually find their way into his work in a
great variety of forms. The more intimately he knows them the
more often they appear. Until his death in 1968 his devoted friend
Sabartés turned up in disguises designed for him with a malicious
humour that revealed at the same time a lasting affection (see
Nos. 169, 248). Among the many portraits of Dora Maar (see Nos.166,
167 and 168) which range from grotesque inventions to faithful
likenesses there were others in which he playfully saw her as a bird,
just as the face of Françoise (see No.196) appeared as a flower or
as the sun, and Marie Thérèse (see No.140) took the shape of the
moon or the sleeping landscape of the earth in both sculpture and
paintings. But for nearly twenty years it has now been the magic
of the eyes and the beauty of Jacqueline (see Nos. 233, 275) that
take the place of honour in all his work as the inevitable recognition
of her devoted presence.

In the same way that Picasso is at ease in a crowd, at a bull fight or
with the local craftsmen and shopkeepers of Vallauris, he is at ease
with his surroundings. He has never sought for the picturesque nor
for an ideal place to live. So long as a house meets with his
requirements for work and provides a minimum of comfort, he asks
for no more. To him the house is an instrument of work rather than a
background for elegant living. As soon as he enters, it begins to
suffer the overwhelming imprint of his presence. Every room
becomes his studio or his workshop and everywhere there accumulates
evidence of his activity. Objects that have found their way into his
life by choice or by chance take their places indiscriminately wherever
they are left and are continually joined by newcomers, while their

223
At 'La Californie', left to right,
Man Ray, Julie Man Ray, the matador
Minouni, Picasso, and Jacqueline
Roque. 1955. Photo by Man Ray.

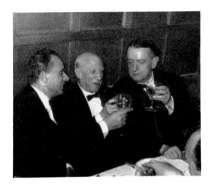

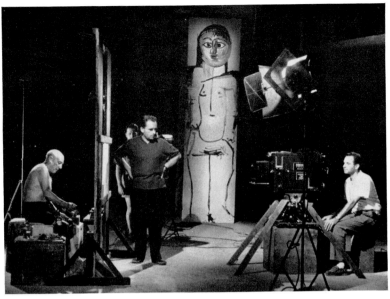

224
Clouzot, Picasso, and Georges Auric, the composer of the music for the film, after the first performance at the Cannes Film Festival. 1956.

225 (right)
Picasso and Henri-Georges Clouzot at work filming *Le Mystère Picasso*. 1955.

226
Picasso with his son Paul, Christine Pauplin and Jacqueline Roque arriving for the first showing of his film. 1956.

neighbours, the objects of his own creation, increase in number incessantly. An alchemist's laboratory would be monotonous in comparison to Picasso's studio.

The constant flow of visitors has been both a pleasure to Picasso and an embarrassment. He grudges increasingly the hours when he is kept from his work but at the same time he accepts honours offered to him by his friends, such as the citizenship of Antibes. Owing to his enthusiastic appreciation of the devotion shown by his friends, the festivities prepared for his eightieth birthday in October 1961 continued for three days on a scale which recalled the fêtes of the Renaissance. However, the great exhibitions held in many cities throughout the world including New York, London, Paris and Tokyo have always met with his refusal to attend.

'La Californie' had rapidly become overcrowded with the prodigious output of paintings, sculpture, ceramics, drawings and graphics. In addition the heteroclite, ever-increasing collection of objects brought as presents extended with the sculpture into the

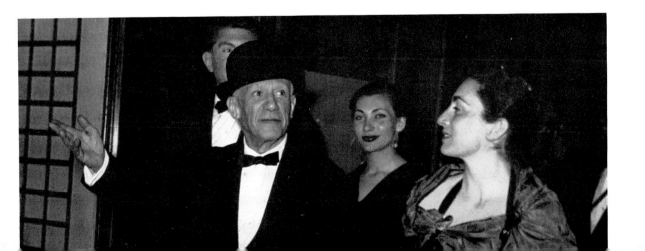

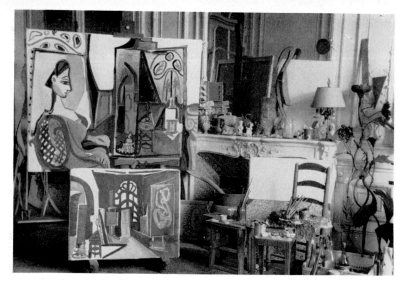

227
The studio at 'La Californie'.
1956. Photo by Lee Miller.

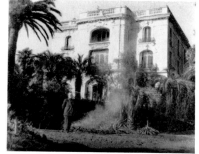

228
'La Californie' with Sabartés in the
foreground. 1956.

229
Interior of 'La Californie'. 1956.
Photo by Jacqueline Picasso.

230
Picasso with the author Claude Roy
and the Russian poet Ilya Ehrenburg
(far left) who remained a devoted
admirer and advocate of Picasso in
Russia for many years. 1954. Photo by
André Villers.

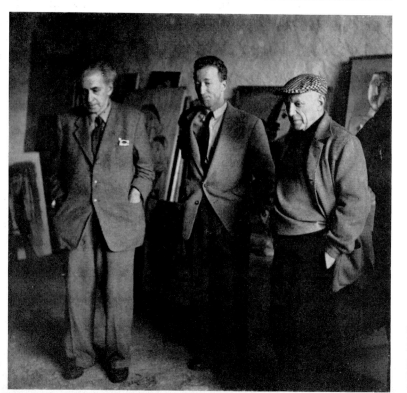

231 (right)
Picasso presides at the bull fight at
Vallauris. On his right are Jacqueline
Roque and his daughter Maïa, on his
left his son Claude and Jean Cocteau.
1955. Photo by Brian Brake.

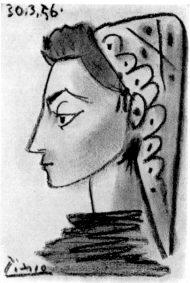

232
Picasso and Jacqueline Roque at
the station. Cannes. 1956.
Photo by Jacqueline Picasso.

233
Picasso: *Jacqueline Roque*. 30 March
1956 (crayon, 11 × 7).
Galerie Rosengart, Lucerne.

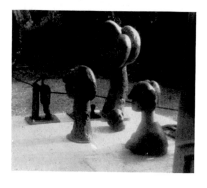

234
A group of bronze heads dating
from the early 30's stand together on
the steps outside with the *Flayed Head*
of 1941 lying among them.
Cannes. 1956.

235
During the autumn of 1956
Picasso made several tall figures from
scrap pieces of packing cases, frames
and drift wood. Afterwards they were
given a permanent homogeneous form
by being cast in bronze. Cannes. 1956.
Photo by Jacqueline Picasso.

236
An enthusiastic procession in the main street of Vallauris passing the entrance to an exhibition of Picasso's ceramics on the way to a bull fight given in his honour. 1955. Photo by André Villers.

237
Picasso joins the band celebrating the start of the bullfight arranged for him. His daughter Maïa stands behind him. 1955. Photo by André Villers.

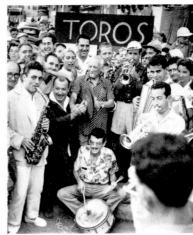

238
In the arena at Vallauris Picasso discusses the bull fight. 1955. Photo by Brian Brake.

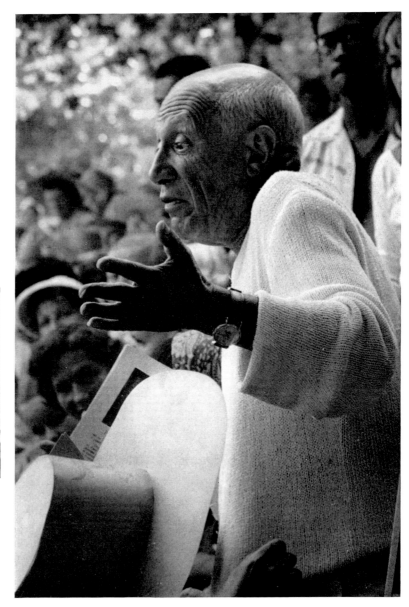

239
Picasso standing at the garden entrance to his studio with a wood figure ready for casting. Cannes. Summer 1956. Photo by André Gomès.

240
Garden sculpture at
'La Californie', cut out of sheet tin
and drawn on with chalk.
Cannes. Summer 1955.
Photo by Jacqueline Picasso.

241
Picasso seated in front of his
canvases. On the floor to the left is a
decorated jar recently fired in the
kilns at Vallauris, and on the right
is the figure of a boy playing the pipes,
cut out of plywood. Cannes. 1956.
Photo by Jacqueline Picasso.

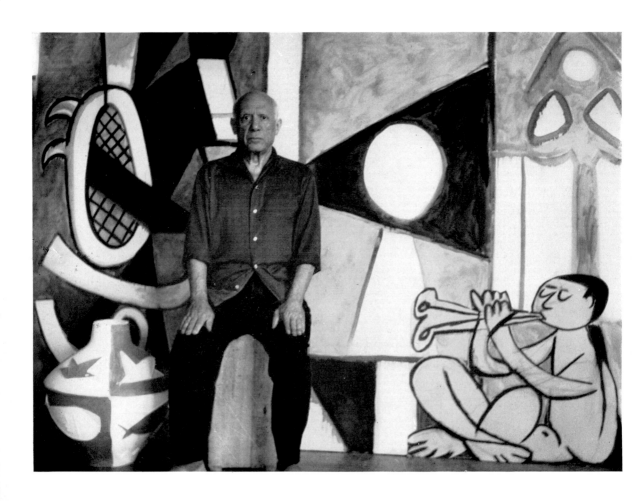

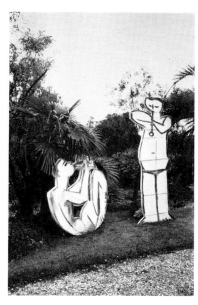

242
Garden sculpture built of ceramic
tiles at 'La Californie', Cannes.
Autumn 1956. Photo by Lee Miller.

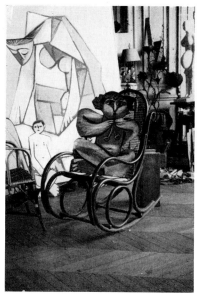

243
Experiments in adding torn pieces
of paper, objects or ornamented
surfaces to pictures have led Picasso
to make up figures cut out of plywood
which he moves around his studio
studying their relationship to furniture
and the pictures against which they
are seen. He enjoys the strange
appearance of a faun seated in his
rocking chair. Cannes. Autumn 1956.
Photo by Hjalmar Boyesen.

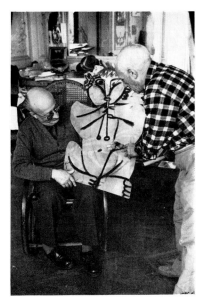

244
Picasso and Sabartés examining a
figure cut out of plywood.
Winter 1956. Photo by Lee Miller.

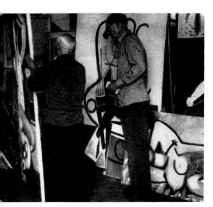

245
Picasso and Alfred Barr at
'La Californie', looking at canvases
that had been painted during the
previous twelve months. Cannes.
June 1956.
Photo by James Thrall Soby.

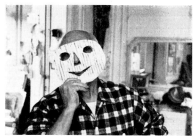

246
Picasso poses for the camera holding
a mask made of ceramic.
Winter 1956.
Photo by Lee Miller.

247
A plywood figure of a pipe-player
finds its place in the garden: Cannes.
1956.
Photo by Jacqueline Picasso.

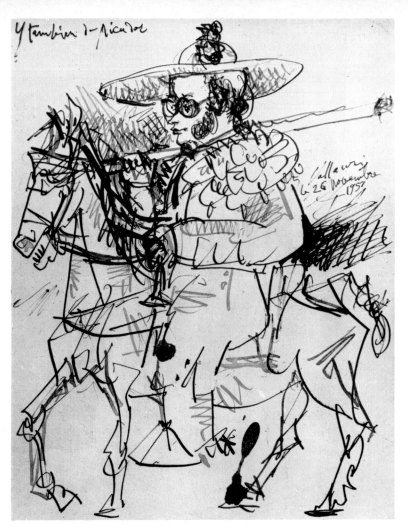

gardens. The top floor finally became the last refuge where Picasso
could find the space and the solitude he needed for his work. It was
there by night with Jacqueline, the only one allowed to be with him,
that he produced in secret the series of variations on Velázquez's
painting *Las Meninas*, while faced by the brilliance of the blue sea
and sky by day he made a series of landscapes of the view from his
window, full of the flight of the pigeons that lived in the dovecote
that he had hammered together for them (see No. 220). During the
same period he also found time to paint in sections the enormous
mural which is now installed in the UNESCO building in Paris
(see No. 222).

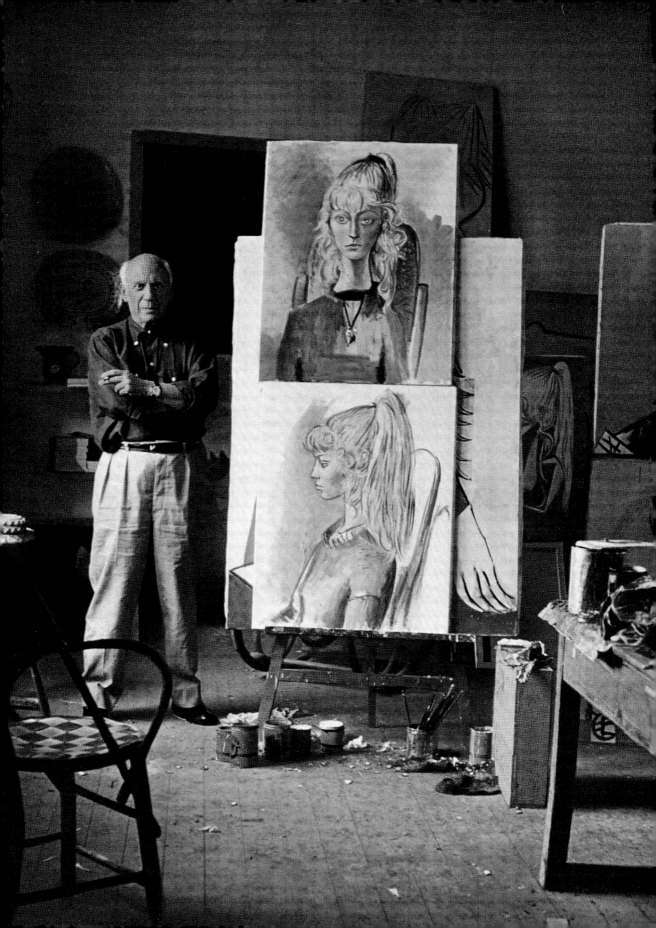

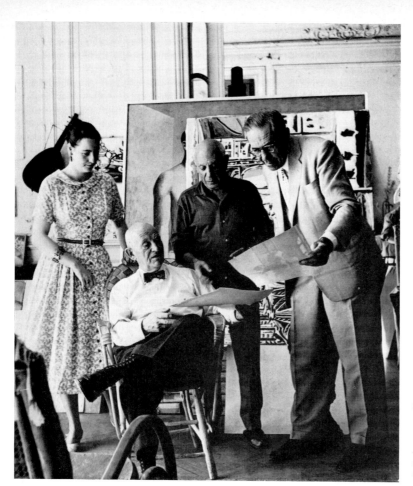

250
Picasso examines photos with Kahnweiler (seated) and his friends from Lucerne, the dealer Siegfried Rosengart and his daughter, Angela. 1958. Photo by André Villers.

251
Picasso: *Arturo Rubinstein* 19.7.'58, lead pencil. Picasso made 21 drawings in one afternoon of Arturo Rubinstein, the pianist, when he called at 'La Californie.' See Zervos: *Picasso*, Vol. 18, pp 77–81.

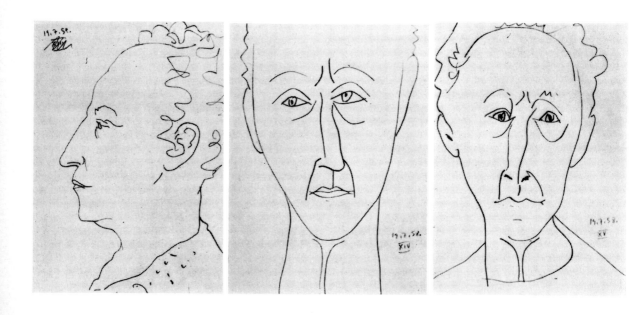

252
Picasso: *Michel Leiris* (drawing with coloured crayons).

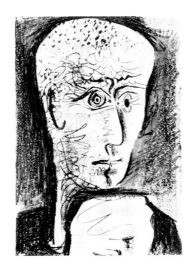

253
Picasso: *Frédéric Joliot Curie*. 1959 (pen and ink). See Zervos: *Picasso*, Vol. 18, p. 101.

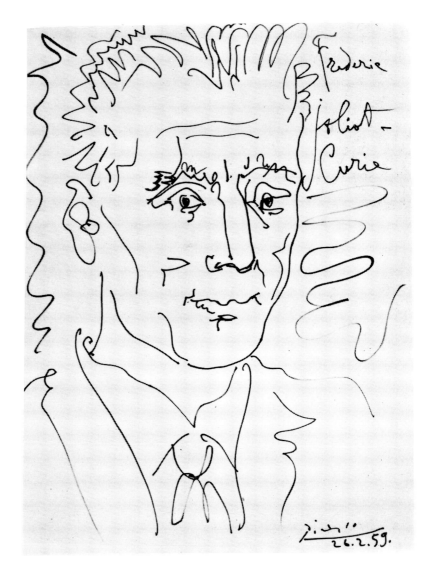

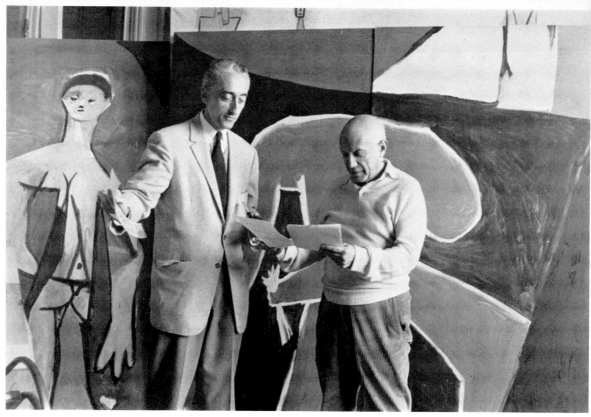

254
Picasso in his studio with Jean Yves
Cousteau the oceanologist. 1959.
Photo by Edward Quinn.

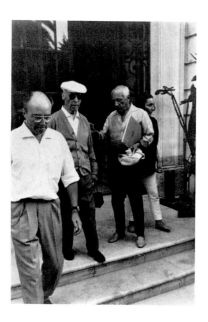

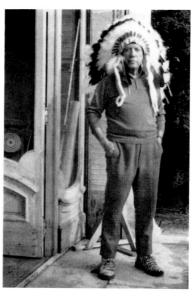

255
Picasso receives the annual visit of his
old friend Pallarés and his son René.
1959. Photo by Edward Quinn.

256
Picasso wearing a Sioux headdress
given to him by an American friend.
1959. Photo by Barbara Bagenal.

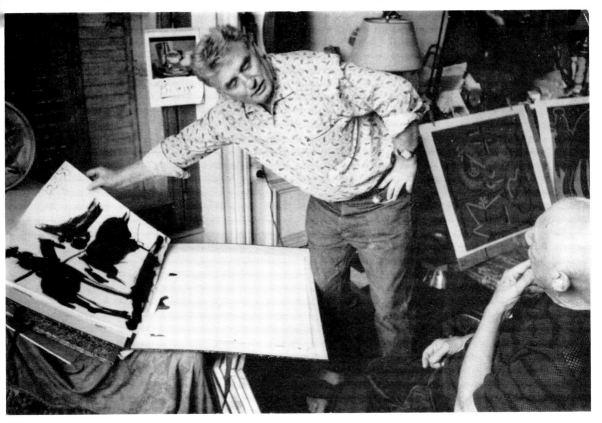

257
Picasso discusses recent drawings and
lino cuts with the painter Edouard
Pignon. 1959. Photo by Edward Quinn.

253
Picasso with old friends, the critic
Clive Bell and Barbara Bagenal. 1959.
Photo by Jacqueline Picasso.

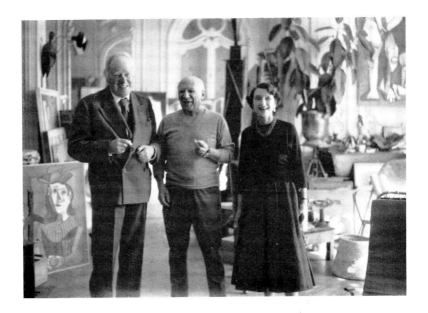

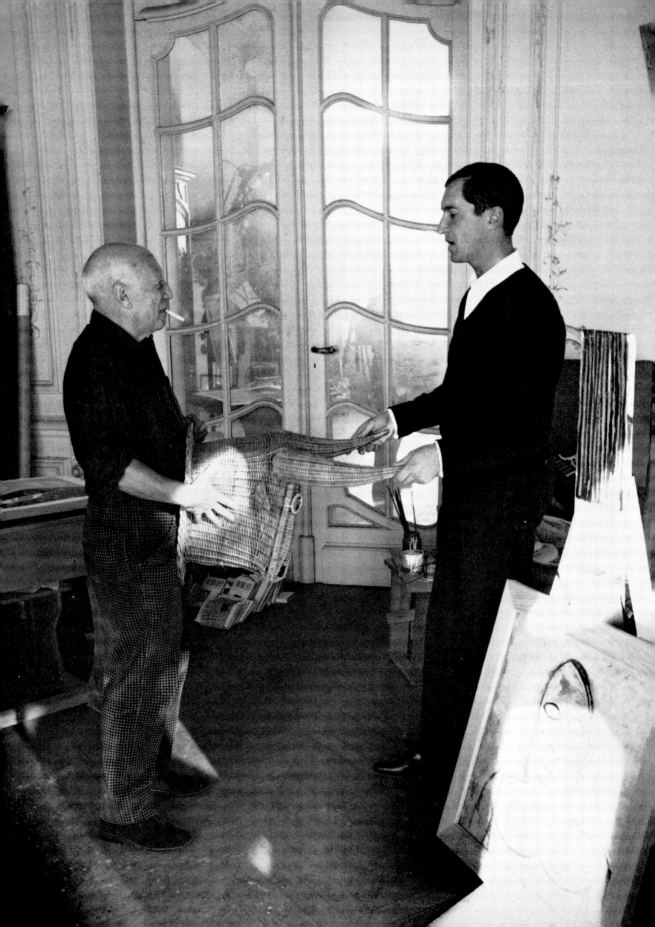

259 (left)
Picasso with a Spanish wicker mask of a
bull takes a lesson in bull fighting
from an expert, the matador
Luis-Miguel Dominguín. 1959.
Photo by Edward Quinn.

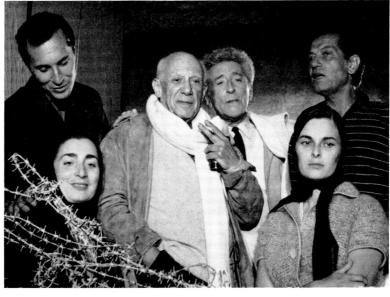

260 (right)
With Cocteau at Les Baux during the
filming of *The Testament of Orpheus*
in which Picasso took part with
(left to right) Dominguín, Jacqueline,
Lucia Bosé and Serge Férat. 1959.
Photo by Lucien Clergue.

261
The children of Dominguín and his
actress wife Lucia Bosé entertained
by Picasso, Jacqueline, her daughter
Cathy with Zette Leiris (seated left) in
the garden at 'La Californie'. 1959.
Photo by Edward Quinn.

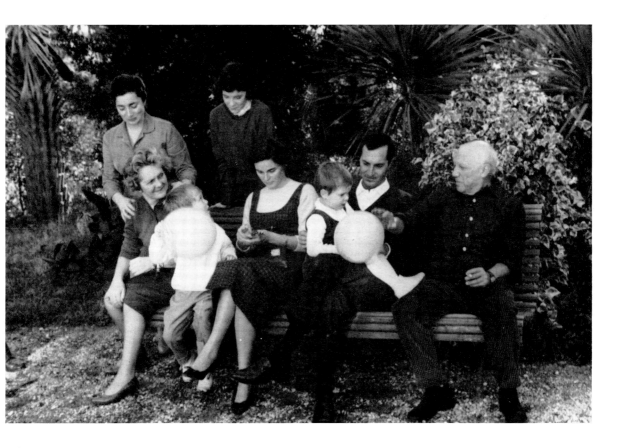

Vauvenargues and Notre Dame de Vie

For some years as building development began to encroach on 'La Californie', Picasso had felt restless. He began to wish seriously for more space for his work and a greater degree of seclusion. With this in mind he bought in 1958 the splendid but severe château of the Marquis of Vauvenargues, surrounded by vast pine forests at the foot of the Mont Sainte Victoire near Aix-en-Provence. He installed his studio in the great seventeenth-century apartments and his sculpture by the fountains and the balustrades at the entrance. The change of scene gave him new interest in colour and he painted with great vigour subjects which had a more pastoral appeal. It was here that he began the series of variations on the *Déjeuner sur l'Herbe* of Manet. After two summers however he began to find that the remoteness of this noble site was too complete. Three years later, in 1961, he moved back to the coast, again to an old Provençal house, the Mas Notre Dame de Vie on the crest of a hill looking towards the little hill-town of Mougins and the Esterelle mountains. Here the seclusion he needed could be found and combined with the amenities of Cannes, the sea, and the availability of his friends the craftsmen who are needed for his work and who live mostly in Vallauris and Mougins or come great distances by way of Cannes or Nice. It had also the advantage that he could build on more studios as the rooms again became overcrowded. But even here the tentacles of the developers are stretching across the terraces below Picasso's windows and the future cannot be regarded with much assurance.

On 2 March 1961 Picasso married Jacqueline Roque at the

262
The Château de Vauvenargues at the foot of the Mont Sainte Victoire. Photo by Barbara Bagenal.

263
Picasso used the great seventeenth-century rooms of the château as his studios. To the right is one of the *Déjeuner sur l'Herbe* series. 1960. Photo by Edward Quinn.

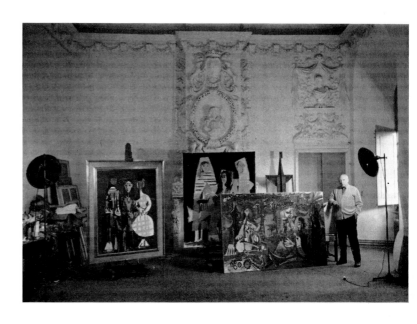

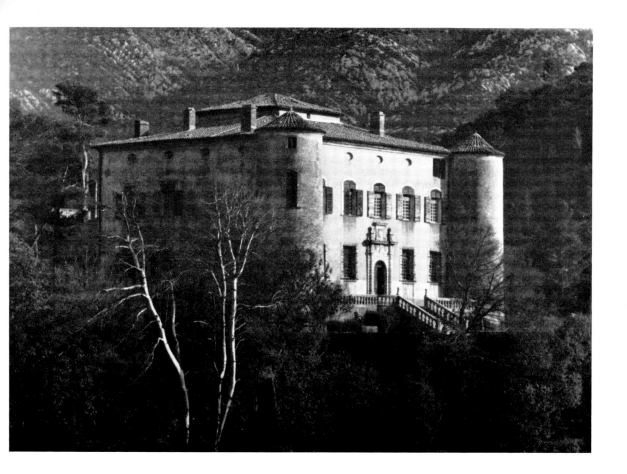

264
The Château de Vauvenargues where
Picasso went to live in 1959.
Photo by Edward Quinn.

Mairie of Vallauris in such secrecy that for more than ten days it
was not known even to their closest friends.

Catalonia

Thanks to the initiative of Jaime Sabartés the city of Barcelona
acquired the fifteenth-century Aguilar palace in the Calle de
Montcada and converted it into a Picasso Museum. It was first
opened in 1963 with a large collection of paintings, drawings and
prints given by Sabartés and increased later with the addition of all
the early works from the municipal museum. In 1968 Picasso added
to this the complete series painted in 1957 of the variations on
Velázquez's *Las Meninas* in memory of his old friend Sabartés who
had died earlier that year. This gift was again greatly augmented in
1970 when Picasso gave all his early work that had been stored in
Barcelona in the apartment of his sister Lola and her husband Dr
Vilató. This second gift amounts to many hundreds of paintings and
drawings. It forms a complete and unique survey and is admirably
exhibited in the appropriate surroundings.

265
Picasso: *The village of Vauvenargues seen from the château.* 1959 (oil).

266
Picasso: *The Arena of Arles with the Rhône in the background.* 1960 (oil). Picasso has watched many bullfights in this ancient Roman arena.

267
Picasso: *View from La Californie at dusk.* 1960 (oil). At this time the builders' cranes began to threaten the view of the sea.

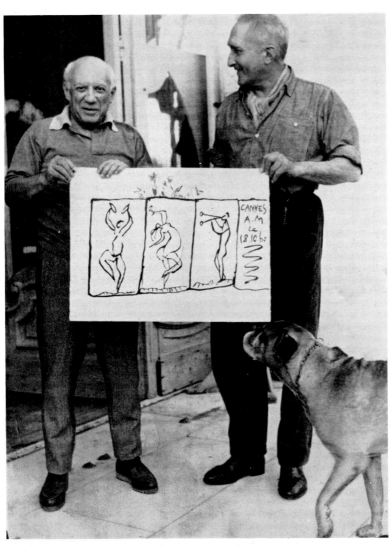

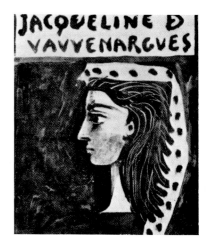

269
Picasso: *Jacqueline de Vauvenargues.* 1959 (oil). See Zervos: *Picasso*, Vol. 18, p. 133.

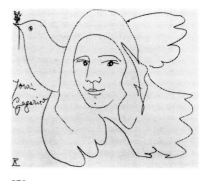

270
Picasso: *Pour Gagarine.* Sketch book drawing. 1961 (lead pencil). See Zervos: *Picasso*, Vol. 19, p. 147.

268
Picasso with François Hugo, the designer of jewellery and skilled craftsman who made fifty large platters in repoussé silver from Picasso's designs. 1960. Photo by Jacqueline Picasso.

271
Picasso and Jacqueline a few days after
their wedding. 1961.
Photo by André Villers.

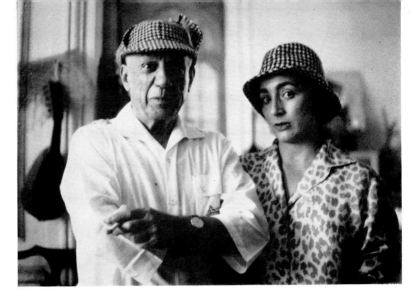

272
A well-lit corner of the interior of
Notre Dame de Vie where Picasso
often works all night.
Photo by Edward Quinn.

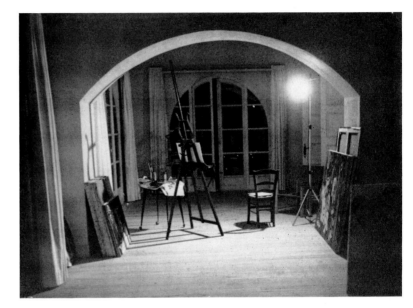

273
Mas Notre Dame de Vie near Mougins
where Picasso has lived since 1961.
Photo by Edward Quinn.

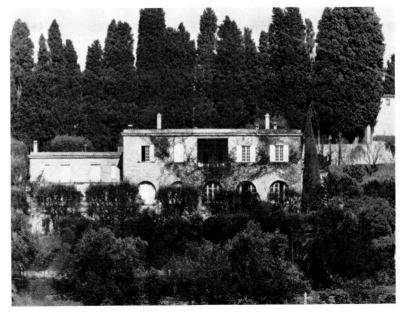

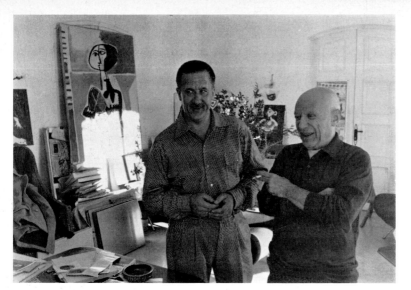

274
Picasso and the Catalan architect
Xavier Busquets for whom he consented
to design large decorative panels
for the new building of the College
of Architects in Barcelona. They were
executed in concrete by Carl Nesjar
in a new sand-blasting technique.
1962. Photo by Edward Quinn.

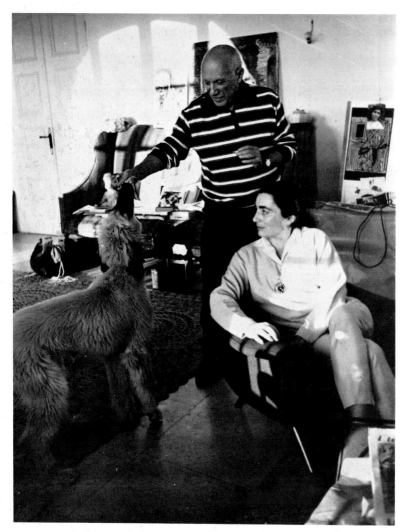

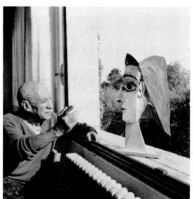

275 (above)
Picasso: *Portrait of Jacqueline*. 1962.
A painted sculpture in sheet metal.
Photo by Lee Miller.

276
Picasso and Jacqueline with their
Afghan hound Kaboul. 1962.
Photo by Edward Quinn.

277 (right)
Picasso: *Woman with outstretched
arms*. D.-H. Kahnweiler in his garden at
St. Hilaire stands beside a monumental
sculpture in sand-blasted concrete
executed by Carl Nesjar from Picasso's
model. 1962. Photo by Barbara Bagenal.

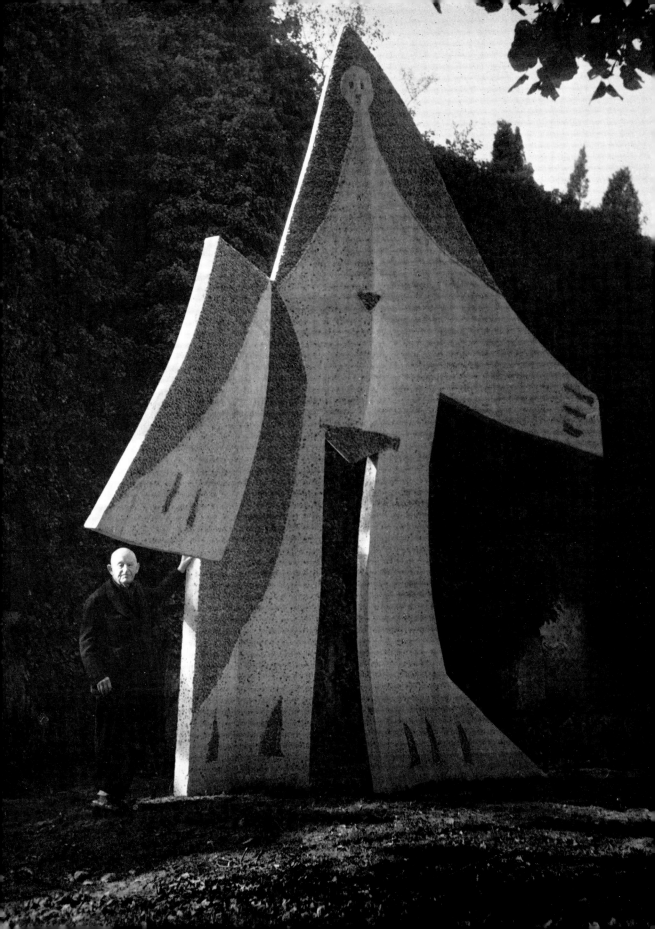

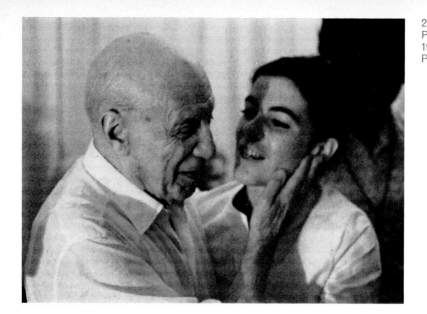

278
Picasso with his stepdaughter Cathy.
1968.
Photo by Lucien Clergue.

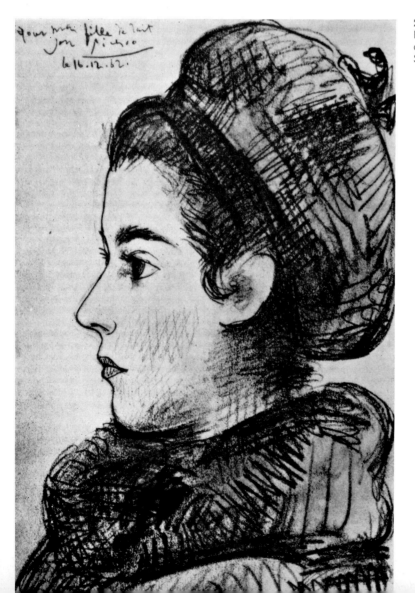

279
Picasso: *Pour ma fille de lait*. Portrait
of Jacqueline's daughter, Cathy. 1962.
See Zervos: *Picasso*, Vol. 20, p. 101.

280
Part of the *Meninas* series in the Museo Picasso.

281
Museo Picasso. Photo by Lee Miller.

282
Entrance to the Museo Picasso in Barcelona.

283
One of the courtyards inside the XVth-century Museo Picasso.

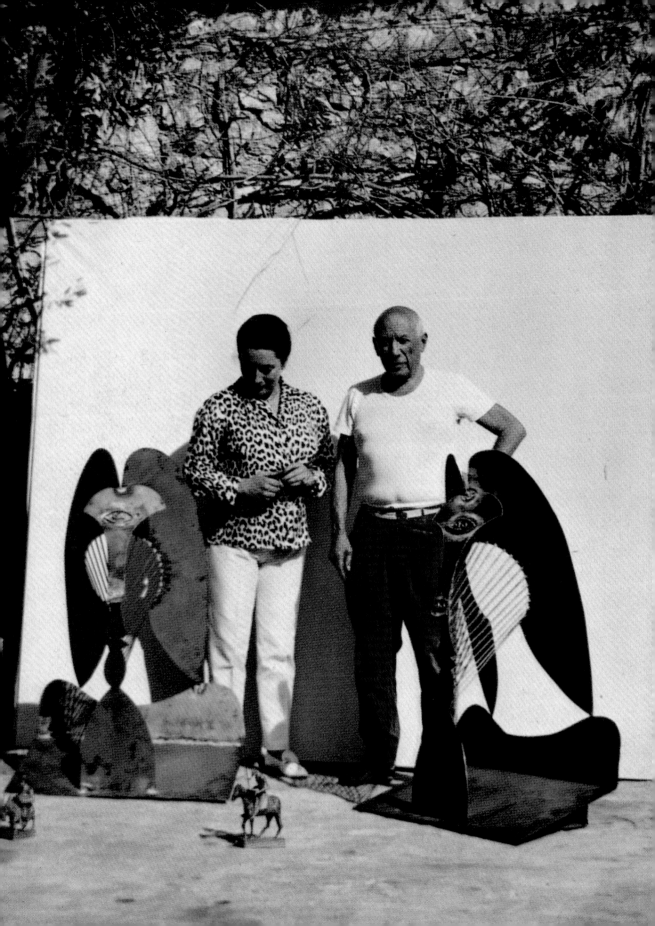

Monumental sculpture

Even before 1930 Picasso had hoped to be able to realise certain ideas as monumental sculptures. This became possible recently when a Norwegian artist, Carl Nesjar, invented a method of building and sand-blasting versions of Picasso's painted sculptures on an imposing scale. The sculptures had originated as cardboard maquettes which were then transformed using welded metal sheets and finally painted and given expression by Picasso. Many of these have now been constructed as monuments in various European countries and the U.S.A.

In 1963 Picasso began a maquette for a monumental sculpture he had been asked to design for the new plaza of the Civic Centre in Chicago. From this engineers constructed an enlargement in Corten steel to a height of 60ft in Chicago and Picasso surprised his clients by refusing any payment.

284 (left)
Picasso and Jacqueline with two versions of the Chicago maquette. The models of Don Quixote and Sancho Panza were set in front to give an idea of the scale of the monument. 1964.

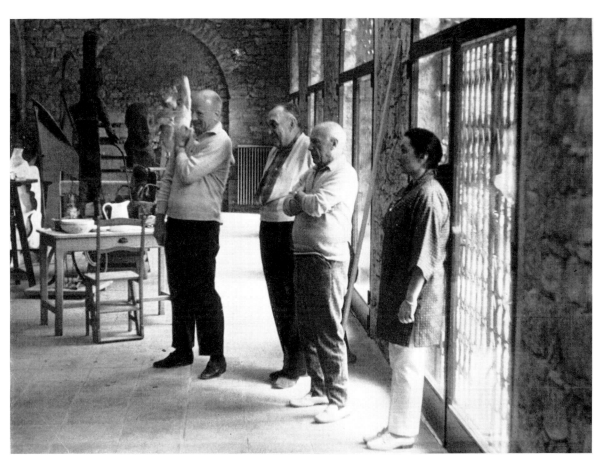

285
Picasso in his sculpture studio with William Hartmann, the architect from Chicago concerned with the monument Thiola, the metal worker who constructed the maquettes, and Jacqueline. 1964. Photo by the author.

286
Part of the sculpture studio with many
sculptures of various periods
including an enlarged version of a
space sculpture in iron rods of 1928
and a cast of Michelangelo's *Slave*.
1965. Photo by Edward Quinn.

287
A view of some of the sculpture which
was shortly to leave for exhibitions in
Paris, London and Rome. 1966.
Photo by Lee Miller.

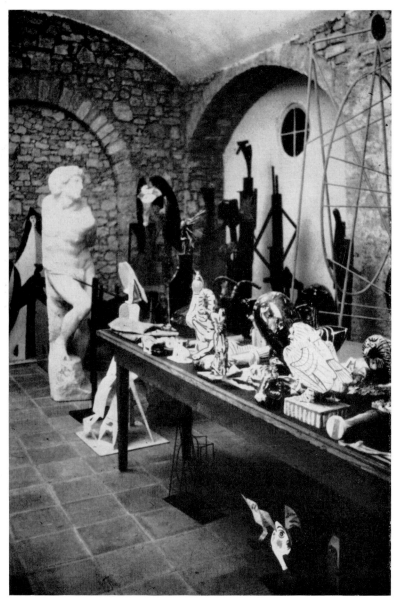

288
Picasso with Jacqueline in his studio.
The aquatint in the background, pinned
over a painting by a friend, is a variation
on Cranach's *Venus and Cupid*. 1967.
Photo by Edward Quinn.

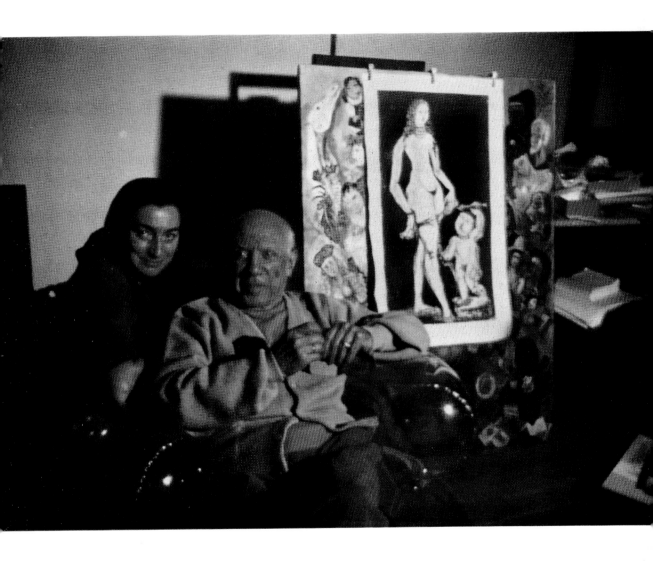

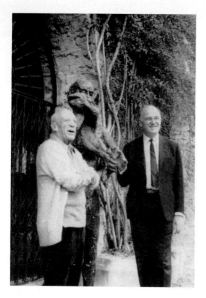

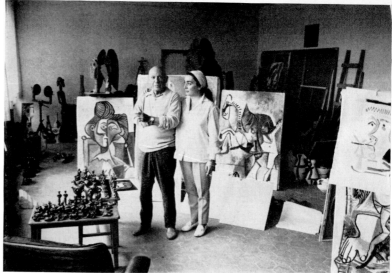

289 (above, left)
Picasso with the Russian pianist
Sviatoslav Richter who came to visit
him on his 85th birthday. 1966.

290 (above, right)
Picasso and Jacqueline in his studio
at Notre Dame de Vie with recent
canvases, small sculptures cast in
bronze, ceramics and maquettes for
the Chicago monument. 1964. Photo
by Edward Quinn.

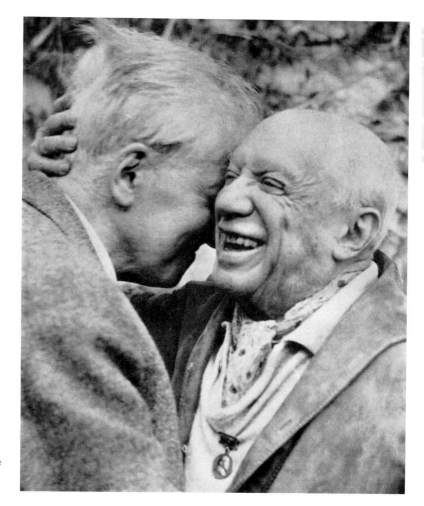

291
Ilya Ehrenburg presents Picasso with
the Lenin Prize conferred on him by the
Soviet Government. April 1966.
Photo Agence France Presse.

292
M. André Malraux visiting the exhibition
of drawings at the Petit Palais with
Jean Leymarie. November 1966.

293a
The French government organized five
exhibitions in Paris in honour of
Picasso's 85th birthday. Paintings were
shown at the Grand Palais, sculpture,
drawings, and ceramics at the Petit
Palais and graphic art at the
Bibliothèque Nationale. Here M. André
Malraux, Minister of Fine Arts, enters
the Grand Palais, while the Republican
Guard stand to attention. Picasso
himself was not present. November 1966.

293b
Visitors queueing to see the Picasso
retrospective on Christmas Day 1966.
Photo Agence France Presse.

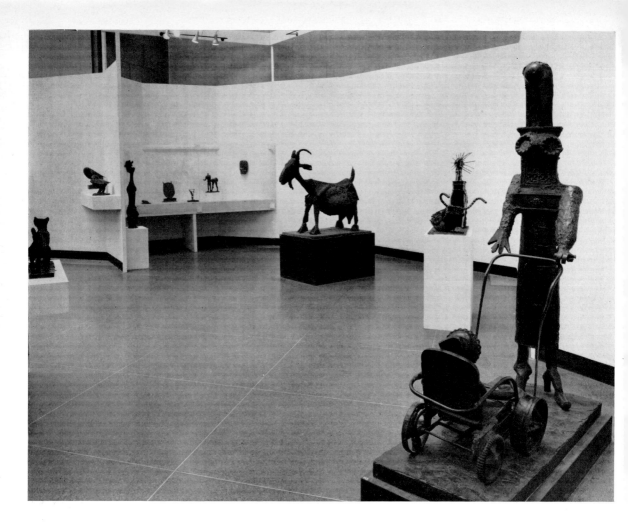

294
Part of the exhibition of Picasso's sculpture shown at the Tate Gallery after it had been seen in Paris and before going on to New York. 1967. Photo by John Webb.

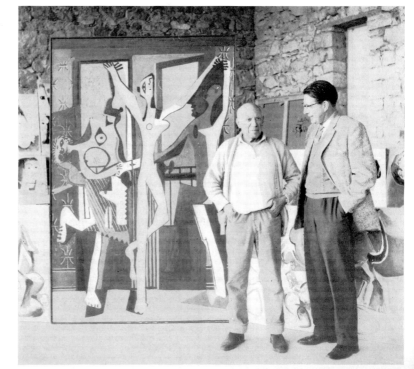

295
Picasso with the author in front of *The Three Dancers* painted in 1925. Having refused to part with this great painting for forty years Picasso finally agreed to allow the Tate Gallery to purchase it in 1965. Photo by Lee Miller.

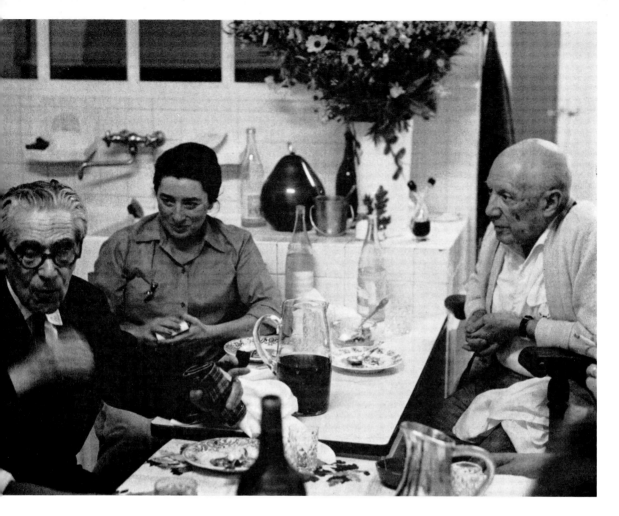

296
Picasso and Jacqueline entertain
Professor René Gutmann to lunch
in the kitchen. Picasso made a drawing
for the cover of Gutmann's book
on cancer in 1956. 1964.
Photo by Lucien Clergue.

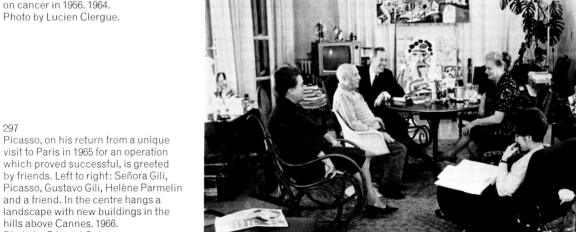

297
Picasso, on his return from a unique
visit to Paris in 1965 for an operation
which proved successful, is greeted
by friends. Left to right: Señora Gili,
Picasso, Gustavo Gili, Helène Parmelin
and a friend. In the centre hangs a
landscape with new buildings in the
hills above Cannes. 1966.
Photo by Edward Quinn.

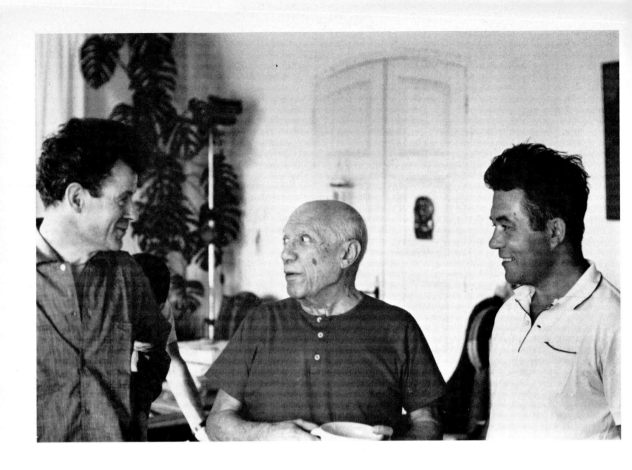

298
Picasso with Jean Leymarie (left), poet, Director of the Musée National d'Art Moderne, Paris, and organizer of the great exhibitions in honour of Picasso's eighty-fifth birthday in Paris in 1966/67 and the writer Pierre Daix. 1967.

299
Gustavo Gili, the Catalan publisher, and the brothers Piero and Aldo Crommelynck, on whose press in Mougins Picasso's engravings are printed, examining proofs with Picasso in preparation for a publication in Barcelona of Picasso's book *El Entierro del Conde de Orgaz*. 1968.
Photo by Lucien Clergue.

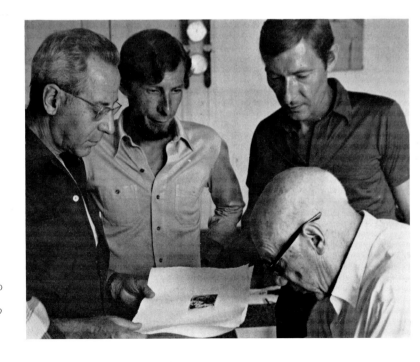

300
Picasso measures hands with
the gypsy guitarist Manita de Plata and
finds they are the same size.
Photo by Lucien Clergue.

301
Picasso with the Spanish poet
Rafael Alberti who wrote the preface
for *El Entierro*. 1968.
Photo Studio Appollot, Grasse.

302
Picasso at Notre Dame de Vie prepares
for a barbecue with Michel Leiris,
Maurice Jardot and D.-H. Kahnweiler.
1966. Photo by Lee Miller.

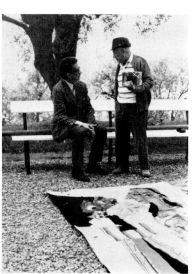 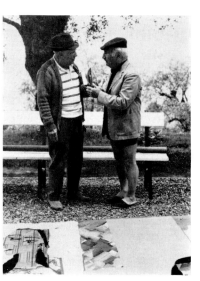

303 (far left)
Picasso and Pierre Baudouin, friend
and expert in tapestry-making. 1970.
Photo by Lee Miller.

304
Picasso and Iliazd, typographer and
publisher of books illustrated by
Picasso. 1970. Photo by Lee Miller.

305
Jacqueline in the gardens of Notre
Dame de Vie with a close friend,
Madame Gris, the widow of Juan Gris.
1970.
Photo by Barbara Bagenal.

306
The exhibition of Picasso's paintings
and drawings made during 1969 filled
the Great Chapel of St Clement and
three other rooms in the Palais des
Papes. 1970. Photo by Marc Riboud
(Magnum).

307 (far right)
Entrance to the exhibition in the Palais
des Papes at Avignon of paintings
and drawings of 1969. June 1970.
Photo by Lee Miller.

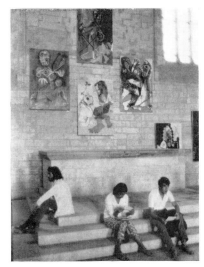

308
The tapestry seen from above. 1970.
Photo by Lee Miller.

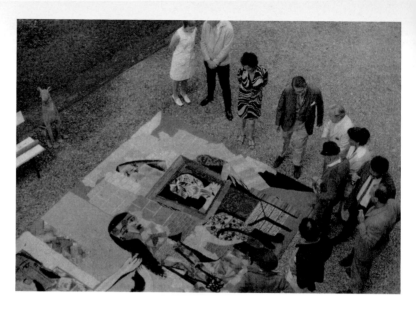

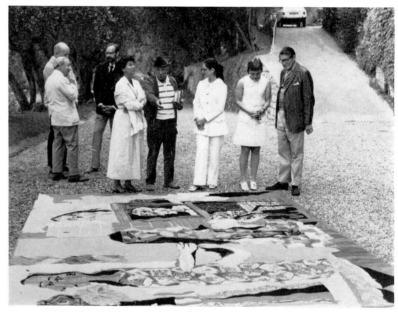

309
A large tapestry woven recently at the
Gobelins factory from a collage
Women at their toilet made in 1937/8
arrives at Notre Dame de Vie and is
spread on the gravel so that Picasso
can view it with his friends from above.
1970. Photo by Lee Miller.

310
Picasso and his visitors examine the
tapestry. Left to right: Joseph
Hirschhorn, William Hartmann (behind),
Mr Woodford, Mrs Hirschhorn, Picasso,
Mrs Woodford, Mrs Hartmann, the
author. 1970.
Photo by Lee Miller.

311
Picasso with the Catalan painter
Antonio Tapiés discusses new
techniques in engraving. 1967.
Photo by Jacint Reventós.

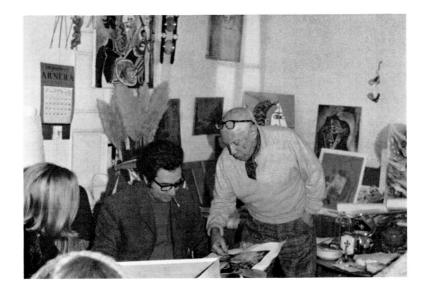

312
Picasso holding the Cubist construction
Guitar (1911) which he gave to Walter
Bareiss and William Rubin (see photo)
as a donation to the Museum of Modern
Art, New York. 1971.

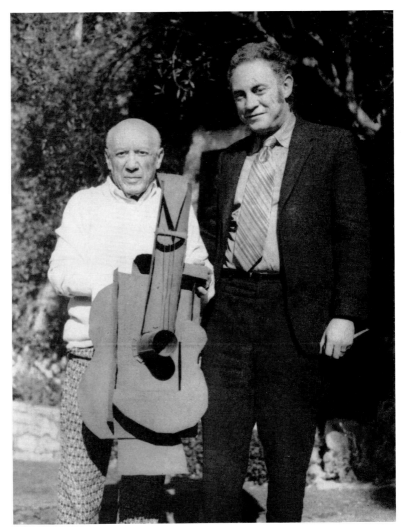

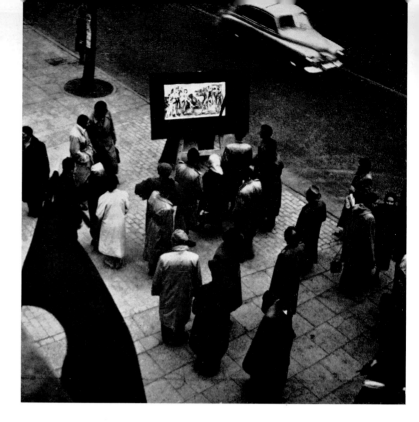

313–314
On a main throughfare in Warsaw passers-by stop to look at a reproduction of Picasso's picture *Massacre in Korea*, displayed in sympathy with the workers of Hungary in November 1956.

Political sympathies

Events in Hungary in the autumn of 1956 disturbed Picasso deeply. Although he is not interested in politics, regarding them as a crafty game outside his sphere, he has continued to be a member of the French Communist Party since 1944. But he was gratified by the news that a large reproduction of a painting of 1951 to which he had given the title *Massacre in Korea* had been exhibited in the streets of Warsaw as a protest against the suppression of the revolt of the Hungarian workers by Russian tanks. This picture, like *Guernica*, had been painted as an outcry against war and violence and its appeal was intended by him to be universal. In November 1956 Picasso signed a letter to the central committee of the French Communist Party, with nine others, expressing 'profound anxiety' and denouncing the veil of silence drawn deliberately over these events. By so doing he was expressing once more his fundamental love of mankind.

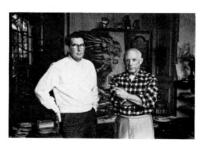

315
Picasso with the author at 'La Californie' in December 1956. In the background standing on its side can be seen the picture *Massacre in Korea*, which had been returned recently from a tour of exhibitions in Paris, Munich, and Hanover.

Picasso's Collection

Picasso has in his possession great quantities of paintings, sculptures, works of art of all descriptions and objects that have appealed to him for some vital reason. He has an intense aversion to throwing out any object that has interested him; among his permanent treasures are such incongruous things as banderillas given to him by a toreador, or a large amethyst with a sealed cavity half full of water mysteriously enclosed within it. There is no sustained attempt to classify his immense and varied collection and a great deal of it is stored away. He has a great number of African sculptures, including some very fine pieces and others of less monetary value, bought in the lean years of his earliest enthusiasm for this art, which were historically important in the development of Cubism.

Among the many paintings and sculptures that Picasso has bought or been given are examples of the work of Le Nain, Corot, Courbet, Gauguin, Cézanne, Renoir, the Douanier Rousseau, Matisse, Braque, Gris, Laurens, Derain, Modigliani, Gonzales, Manolo, Max Ernst, Man Ray, Miró, Beaudin, Balthus, Adam, Pignon, and his father, José Ruiz Blasco.

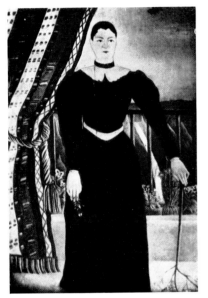

316
Henri Rousseau (Le Douanier): *Portrait de Femme.* This early large painting of Rousseau was discovered by Picasso among piles of rubbish in the Montmartre shop of the Père Soulier in 1908 and bought for five francs. Soulier, who knew it was a Rousseau, thought it of so little value that he told Picasso that the canvas would be useful to him to paint over. Picasso at once appreciated the astonishing strength and originality of the picture and gave it a prominent place on the walls of his studio at the Bateau Lavoir. It hung there above its author during the famous banquet given in Rousseau's honour soon after its purchase. Picasso still claims that it is one of the pictures he loves above all others.

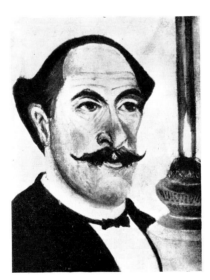

317 (above)
Henri Rousseau (Le Douanier): *The Representatives of Foreign Powers come to salute the Republic in Sign of Peace.* 1907.

318 (left)
Henri Rousseau (Le Douanier): *Portrait of the artist with a lamp.*

319
Cézanne: *Le Château Noir.* 1904–6.

320
Still life with oranges by Matisse
and in the foreground the skull of a
hippopotamus.

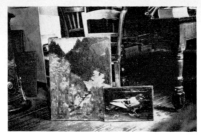

321
A landscape by Gauguin, and a
painting of a pigeon by José Ruiz
Blasco.

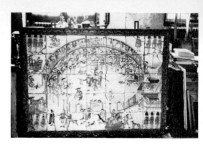

322
A picture of a bull fight
(seventeenth-century Spanish tiles).

324 (left)
An early painting by Derain and
two early landscapes by Matisse.

325
Balthus. Painting 1938.

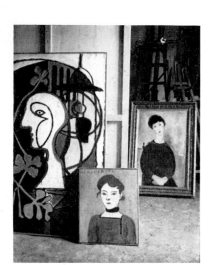

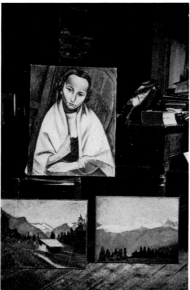

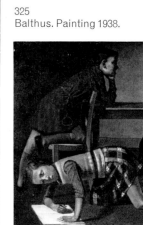

323
Left to right: a painting (1931)
by Picasso, a portrait by Matisse of his
daughter, Marguerite, given to
Picasso by Matisse about 1908, and a
portrait by Modigliani.

Photos taken in the studio, rue des
Grands Augustins, by Lee Miller.

326
On the floor, a Nude (1907) by Picasso
and the head of an Ibex by Courbet.

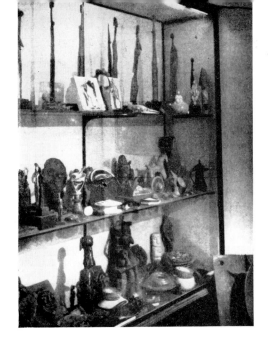

327
A glass case in the Paris studio contained rare and fragile objects. On the top shelf were tall wood sculptures of 1931, later cast in bronze, plaster casts of prehistoric female figures and the skulls of birds. On the second shelf among masks from the South Seas stands a version of the *Verre d'Absinthe,* 1914, and on the bottom shelf is a wooden hand from an Easter Island carving.
Photo by Sidney Janis.

328
Corner of a mantelpiece in the rue des Grands Augustins crowded with objects. In the centre, a bronze by Laurens overpainted by Picasso. On the right, *Head of a bull* in brass by Adam.

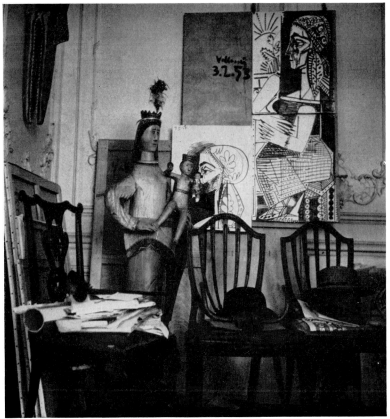

329
Heterogeneous objects in a corner of the studio at 'La Californie', Cannes. 1956. Photo by Douglas Glass.

Picasso at ninety

While Picasso in recent years has tended to become more
of a hermit engrossed in his work and going out into the world
very little, his reputation has continued to grow. It is no
overstatement to say that no artist has ever achieved such
widespread fame during his lifetime.

Yet he has in no way changed his style of living which
remains modest and frugal, giving him the time he demands for the
work that flows continuously from him with astonishing energy.
Even so he still welcomes a more limited number of friends, jokes
with them with Rabelaisian delight, asks with Spanish courtesy for
their latest news and listens attentively to their comments when he
shows them his work. For he has not lost his habit of questioning
and doubting everything and this perhaps is the secret of his
astonishingly youthful vigour, the suppleness of his thought and his
exceptionally accurate visual memory. His output is still prodigious
and the many different media he uses – engraving, drawing, painting,
sculpture, ceramics and writing – vary with his latest inspiration,
producing new wonders from the turbulent richness of his
imagination. The series of 347 engravings, brilliant and erotic, made in
1968 between March and October, and the great exhibition in the
summer of 1970 at the Palais des Papes in Avignon of paintings and
drawings all made during the previous year, are sufficient proof of
his phenomenal vitality and the acute penetration of his vision as
he now approaches his 90th birthday. In his old age Picasso remains
the revolutionary and is at the same time the symbol of a revolution
in art in which he has been the major figure for over sixty years. He
has changed our vision of the world and our understanding of life.
Our gratitude to him is immense.

Map with dates indicating the places where Picasso has lived or visited

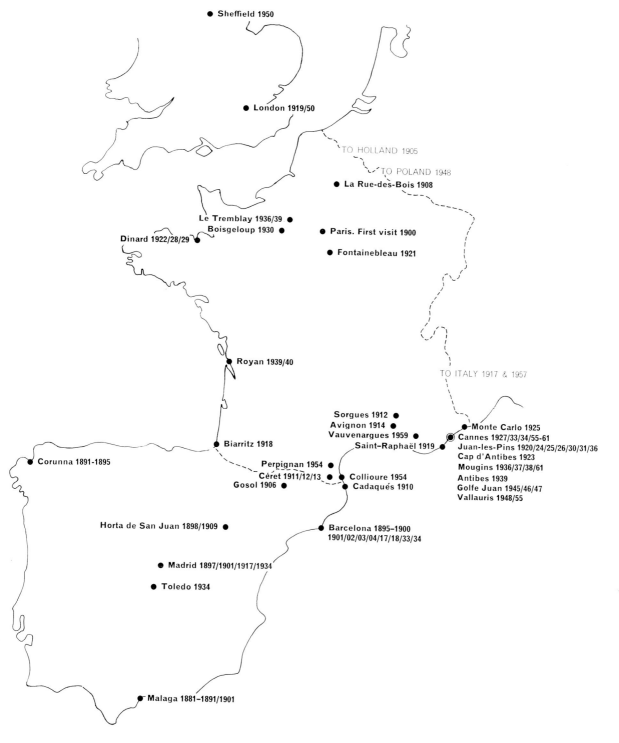

Sheffield 1950

London 1919/50

TO HOLLAND 1905

TO POLAND 1948

La Rue-des-Bois 1908

Le Tremblay 1936/39
Boisgeloup 1930

Dinard 1922/28/29

Paris. First visit 1900

Fontainebleau 1921

Royan 1939/40

TO ITALY 1917 & 1957

Sorgues 1912
Avignon 1914
Vauvenargues 1959
Saint-Raphaël 1919

Biarritz 1918

Perpignan 1954
Céret 1911/12/13
Gosol 1906

Collioure 1954
Cadaqués 1910

Monte Carlo 1925
Cannes 1927/33/34/55-61
Juan-les-Pins 1920/24/25/26/30/31/36
Cap d'Antibes 1923
Mougins 1936/37/38/61
Antibes 1939
Golfe Juan 1945/46/47
Vallauris 1948/55

Corunna 1891-1895

Horta de San Juan 1898/1909

Barcelona 1895–1900
1901/02/03/04/17/18/33/34

Madrid 1897/1901/1917/1934

Toledo 1934

Malaga 1881–1891/1901

Index